Santa Clara Pottery Today

Santa Clara Pottery Today

Betty LeFree

Published for the
School of American Research

UNIVERSITY OF NEW MEXICO PRESS
Albuquerque

Number 29
Monograph Series
School of American Research
Douglas W. Schwartz, General Editor

Preface

I began a technological study of Santa Clara pottery at the pueblo in the summer of 1968. The Wenner Gren Foundation (Grant 2314-1829) supported this fieldwork. I interviewed three potters and their husbands —Helen and Kenneth Shupla, Belen and Ernest Tapia, and Flora and Ramon Naranjo—and photographed and recorded the process by which they made pottery. One purpose of the study was to determine changes and innovations in Pueblo pottery since Carl E. Guthe's fieldwork in 1921 at the pueblo of San Ildefonso.

I wish to extend my sincere appreciation to the potters and their families, without whose patience and help this study would not have been possible.

For information regarding the marketing of Santa Clara pottery, I would like to thank Mr. and Mrs. Donald Traub of the Wooden Indian Trading Post in Embudo, New Mexico, Mrs. L. J. Clark from the Denver Museum of Natural History, C. M. Everhart from the Western Trading Post, Denver, and Mrs. R. D. Helzer from the Deer Dancer, Denver.

I am further indebted to Dr. Alan P. Olson, Anthropology Department, University of Denver, who directed and guided the research; Mrs. Kate Peck Kent, Anthropology Department, University of Denver, who assisted in directing the research; and Arnold Withers, Anthropology Department, University of Denver, who was on my thesis committee. Mrs. Marjorie Lambert of the Museum of New Mexico in Santa Fe suggested the study of Santa Clara pottery and introduced me to two of the potters. Mrs. L. W. Noffsinger prepared the drawings of designs. The late Dr. Willard W. Hill was kind enough to lend me his unpublished manuscript on the Santa Clara Indians. Howard Romback of Denver Brick and Pipe did a very extensive study on the chemical and thermal analyses of the pottery clay from Santa Clara.

Finally, my husband and four boys gave me a great deal of encouragement and help.

Contents

MAP

FIGURES

PLATES

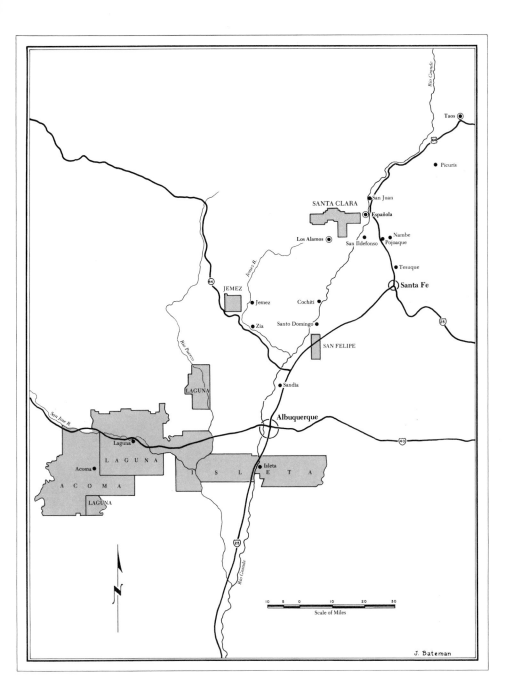

Introduction

The art of pottery manufacturing has had a long history in the Southwest. The earliest stimulus for making pottery is believed to have come from Mexico. Archaeologists in the Rio Grande Valley have recorded a crude, undecorated pottery that appeared around A.D. 700.

Pottery, of course, was utilitarian until metal utensils replaced it for home use. In the late 1800s, the Indians began to produce pottery for the tourist trade. More recently—since, say, the early 1950s—interest has grown in the non-Indian world in collecting good Indian crafts. Indian art fairs all over the Southwest give awards and prizes to stimulate new interest among the Indian potters in achieving excellence in their wares and innovative styles. Good potters are extremely proud of their artistic ability. An intense home industry has grown up, bringing the good potter higher wages and recognition. The price of pottery has steadily risen.

One of the most viable contemporary ceramic expressions in the Rio Grande Valley of New Mexico is that of the pueblo of Santa Clara. A Tewa pueblo, Santa Clara is located on the west bank of the Rio Grande, 20 miles north of Santa Fe and 15 miles northeast of Los Alamos, on State Highway 30, which connects Española with the Pojoaque–Los Alamos highway. It is near the mouth of Santa Clara Creek, one of the few small western tributaries that carry their water to the Rio Grande.

The altitude at Santa Clara Pueblo is 5,600 feet. The Indian reservation comprises 45,742 acres. A census taken in 1963 by the Bureau of Indian Affairs recorded 535 residents. The length of occupation at this particular pueblo is difficult to ascertain, but it was probably founded in the fourteenth century sometime before the coming of the Spanish.

Many exceptionally good artists are now producing pottery at Santa Clara. Some have introduced new styles: for example, Lela and Van Gutierrez and their children, Margaret and Luther, who continued after their parents' deaths; Camilio Tafoya, his daughter, Grace Medicine Flower, and his son, Joseph Lonewolf. Others year by year gain recognition for the quality of their traditional pottery. Helen Shupla, Belen Tapia, Flora Naranjo, Christina Naranjo, Teresita Naranjo, and Margaret Tafoya are all excellent potters, and there are numerous others (see Appendix C).

Several other pueblos also produce distinctive pottery. San Ildefonso, a neighbor of Santa Clara, is the home of Maria Martinez, the famous potter who has done more to create an interest in Indian pottery than almost anyone else. Tony Da, Santana, and Adam, all of whom are related to Maria, have followed in her footsteps. Blue Corn, Rose Gonzales, and Rose's son, Tse Pe, are also superior potters from this pueblo.

The Polished Black wares produced by Santa Clara and San Ildefonso are very similar to the untrained eye, but there are some differences between them. San Ildefonso pottery has thinner vessel walls, and feather designs are more typical of San Ildefonso. Maria's pottery has a distinctive black metallic appearance. Most of the carved ware, on the other hand, comes from Santa Clara.

Recognized potters at Acoma Pueblo include Lucy Lewis and her daughter Emma Lewis, Marie Chino and her daughters Rose, Grace, and Carrie, Jessie Garcia, Lolita Concha, and Stella Chitiva. At Cochiti Pueblo, Helen Codero and Serafina Ortiz make story-teller figurines. Potters producing the famous Hopi pottery in Arizona include Frog Woman, Feather Maiden, Fawn, Elizabeth Smith, and the Nampeyo family. Reyes Butler and Santana Melchor are among the better known potters at Jemez Pueblo and Santo Domingo Pueblo, respectively. There is a steady trend among the other pueblos to revive and improve the art of pottery making.

The novice buyer of pottery today should look for characteristics that make one piece more valuable than another. The body

of the vessel, both the interior and the exterior, should be free of pits or lumps, symmetrical, and smooth. The rim should be uniform. The slip should be evenly applied. The surface should be free of grooves made by the polishing stone. Painted designs should be evenly spaced. Design outlines should be uniform and brush strokes on the filled areas should cover the polished area underneath. On carved pottery, the depth of the carving should be the same over the whole vessel. There should be no black smudges on the redware or buff areas on the blackware. Most potters now sign their pottery, with the exception of beginners, and it is wise to purchase signed pieces. The buyer should shop carefully and buy pieces that he likes. Indian art should be purchased from a reputable dealer.

A craftsman can follow the steps shown in this book and make similar, if not identical, pottery, but commercial clay has to be altered and more grog (temper) added. One suggested mixture for the clay is 60 percent fire clay, 20 percent grog, and 20 percent ball clay. There is no evidence that a ceramic kiln can duplicate the results of the Indian's firing for the blackware, as the carbon from the smothering process has to be driven into the vessel. Experimentation and patience are probably the best teachers. It has taken all good Indian potters many years to learn to produce their beautiful wares.

Santa Clara Pottery

This is a description of pottery making at Santa Clara Pueblo, from the gathering of clay and temper to the finished product, as observed in the summer of 1968. Accounts of the same processes recorded by previous investigators (Jeançon 1906; Guthe 1921; Hill 1940) differ in some respects from this study. The discrepancies may, in part, be due to observations of different potters and pueblos, but they are probably better explained as changes over time.

The Potters

Three of my informants agreed that in 1968 more than sixty women were actively involved in pottery making at Santa Clara; in addition, a number of men and some children regularly took part in the craft (see Appendix C).

Most of the expert potters perform some phase of this activity every day throughout the year. However, more time is spent in making pottery from May to October. The potters start modeling after their household chores are finished, usually at 8:00 or 9:00 in the morning. If they are firing, they may start as early as 6:00 A.M., before it is hot or windy. They work most of the day and even into the night, especially if they are preparing for an important fair or in the summer months when tourists come to the pueblo to purchase pottery. As many as ten hours a day may be spent making pottery at these times.

Thirteen girls and two boys ranging in age from eight to nineteen worked at the craft. They modeled the *animalitos*—little clay figures of animals—while their mothers slipped and polished for them. The youngsters learn by watching their mothers and by experimenting. None of their mistakes are corrected, as their teachers believe that they learn from mistakes. In spite of the number of young people involved, most of the women over thirty expressed concern that the children are not interested in learning the art and may not become potters when they are grown.

At least four men (Ernest Tapia, Camilio Tafoya, Luther Gutierrez, and Joe Tafoya) who were not employed outside the pueblo worked as full-time potters. Other men often assisted their wives by painting or carving vessels after work.

The craft provides extra income for some potters and is the sole source of income for others. The market for pottery is not seasonal but year-round. Since prices increased during the 1950s, pottery making at Santa Clara has become very competitive. Secrets surrounding the locations of paint and even unusual processes are often guarded closely. Good friends will, however, get together to polish pottery in groups reminiscent of the quilting bee. Family groups model, slip, or paint pottery in the evenings, especially in preparation for a big fair. Potters often model, slip, or carve pottery for each other; one artist from Santa Clara is reported to have modeled pottery for Maria at San Ildefonso. The artists feel an obligation to assist each other if they are asked to do so, perhaps in exchange for clay or "sand" (the volcanic tuff used as a tempering agent), or in order to be considered unselfish and cooperative. Socially and economically, this craft plays an important part in the lives of the Santa Claras.

Gathering and Preparing the Body Clay

The body clay is the modeling clay used by Santa Clara potters for forming their vessels. Only one clay is used for this purpose, although the exterior surface may be decorated in a

number of different ways. The body clay is a montmorillonite mixed-layer clay of 10 percent quartz, 25 percent kaolinite, and 40 percent iron-stained illitic-type silt and clay colloid. A chemical analysis showed that the reddish color appears to be due to the iron; the other potential colorants are not present in sufficient quantities to affect the color during firing.

In 1880 Stevenson recorded:

> . . . The clays used by Santa Clara Indians are of a brick-red color, containing an admixture of very fine sand, which, no doubt, prevents cracking in burning, hence dispenses with the necessity of using lava or pottery fragments, as is the custom of the Indians of the western pueblos (1883:331).

Harrington gave this account of the material used for pottery:

> The three materials in common use at Santa Clara are *Na p*, clay; Shunya, tempering materials; and *p'i*, red paint. Formerly tha'u was used as sizing on painted cream-colored ware. The clay which has a reddish color is obtained at a place called *NA Pi' i we*, a clay place which is almost a mile west of the pueblo. The tempering material is obtained near a high hill, seven or eight miles northwest of the village which is called *MAKAWA oky*, on account of its height (1916:127–28).

Two pits of clay were in use on the Santa Clara Reservation in 1968. One is about 3.8 miles from the pueblo in a canyon west of State Highway 30. This quarry is some distance from the road and is difficult to reach, but it was popular with some of the potters. The second pit is 4.3 miles from the pueblo, east of Highway 64–84. I was told that this pit had been used for six or seven years. Modern vehicles are, of course, used for transporting the clay from pits to the pueblo. Gathering clay is a cooperative effort between men and women. Occasionally, more than one family will go together to gather clay. Usually a family will collect all that can be carried in its vehicle.

A pick or a file is used to pry large lumps of clay from the

quarry. (The second pit mentioned previously had been dug to a depth of 34 inches by this process.) The clay chipped loose by the potter is moist and reddish-brown with green spots. When asked if the spots affected the pottery, one potter said they did not. The loosened lumps of clay are gathered either on a shovel or with the hands (Fig. 1) and put into a large metal container, which is placed in the vehicle.

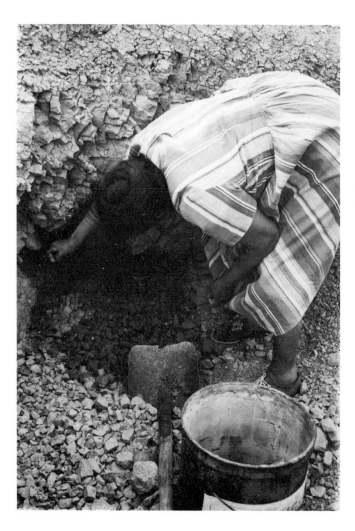

Figure 1. Gathering clay from the pit (Helen Shupla)

My informants can remember a certain amount of ceremony involved with gathering clay, but no ritual was practiced in 1968. Ritual connected with gathering clay was mentioned by Hill:

> While pottery-making was not rationalized in mythology, clay was referred to as "mother clay." "It was believed to have a soul or deity" (informant). For this reason, gathering it involved ritual. Sacred meal was always scattered over the site. "You must treat the clay right, if you do, it will treat you right" (informant).
>
> Illness was believed to result if the proscriptions in gathering were ignored. Curiously, if the pottery cracked during drying or firing, this was attributed to technical ineptitude rather than ritual breach (1940).

Jeançon's observations agree with my findings in that he observed no ritual in the gathering of the clay. His description indicates that the event had a social character I did not see, however:

> The gathering of clay and sand was often an excuse for sort of a picnic. More often than not, several families would combine their efforts, or a group of friends would get together, or several women cronies would join in a party. All of them would start early in the morning, taking food for the noon meal. . . . The babies, if there were any, would be bedded down on shawls and blankets with one of the children, or an older man or woman to keep an eye on them. The women would scatter and search for the best deposits, the men saunter off to gather medicinal herbs, sticks for arrows or bows, bright stones, or sit in the shade of a tree and meditate. Perhaps the man had brought a shoe to be mended or a piece of broken harness that needed attention or some other light task. . . . The noon meal is an occasion of mirth and joking. Should there be a girl in the party who is being courted by some boy, she is teased at great length, sometimes this becomes so personal as to be embarrassing, but it is all done in the spirit of fun and

without malice. A short rest followed after the meal and the work is resumed. Very often yellow ochre beds, kaolin, or white earth beds are in the same neighborhood as the clay and sand beds, and when this is the case, all these are gathered at the same time. . . . When sufficient material of all kinds had been gathered, the party returned in their wagons to the village (1906).

The clay is not treated in any way at the pit. When it has been collected, it is brought home and laid out on tins in the sun to dry. The potter explained that the clay has to be dried before it is soaked. Drying time depends on the weather and the needs of the potter. If the weather is hot, the clay may be dried in two days. It is turned occasionally so that it will dry evenly (Fig. 2).

The dried clay is put in a washtub and enough water is added to cover it. After it has soaked from two to four days the potter pours off the water. She then adds clean water and dumps it off, repeating this process until the water is clear. Finally she adds water again and stirs the clay to form a solution that will pass through a sieve. Small rocks are sorted out as the potter presses the clay through her fingers, breaking up any lumps while it is still in the washtub (Fig. 3).

Figure 2. Drying the clay

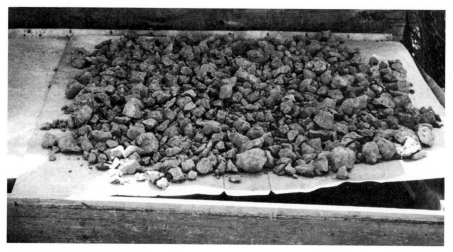

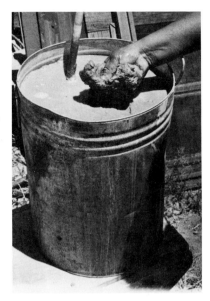

Figure 3. The clay added to the water for soaking

The sieve is a window screen nailed tightly to a rectangular wooden frame 4 inches high, 16 inches wide, and 20 inches long. Clay is dipped with a cup from the soaking bucket onto the mesh. The screen is moved back and forth in a rolling motion until all particles smaller than the mesh are sifted through. The residue is thrown away; none of the sludge is forced through the screen. After each sifting, the clay is stirred with the hand and water is added as necessary to keep the mixture about the consistency of a thick milkshake (Fig. 4).

The potter "sets up" as much clay as she will need for several days. The clay is ready to mix with the tuff or "sand" after a day or two, when the water has evaporated slightly from the mass. Broken or cracked pieces of unfired pottery are added at this time to absorb some of the excess water. They disintegrate rapidly and become part of the clay mass. The tub of sifted clay is covered with a cloth, which absorbs excess water and is frequently wrung out and replaced over the clay. The clay is left outside until it is ready to be mixed with the sand. (The yield after mixing of the clay shown in Figs. 7–9 was estimated by the potter to be enough to make seventy vessels of varying sizes. The

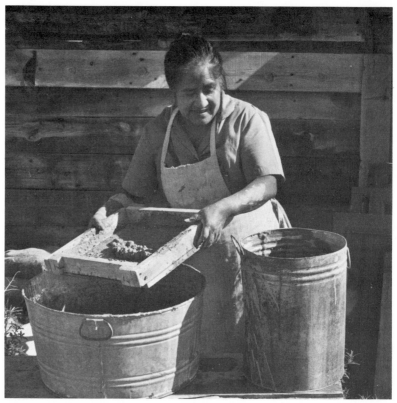

Figure 4. Sifting the clay (Helen Shupla)

sifting process for this amount took about an hour and fifteen minutes.)

Preparation of the clay is somewhat differently described by Jeançon and Hill. According to Jeançon:

> . . . It is first mashed, then ground and pounded into almost dust on slabs of stone reserved for this purpose and often consisting of old fragments of discarded metates. Small stones and other foreign materials are carefully picked out by hand and thrown away. The powdered mass is thoroughly sifted and set aside (Douglas 1931:1).

Hill's observations in 1940 were:

When the clay was first dug, it was often damp and on arrival in the village was placed on the roof top until thoroughly dry. Then it was put on a large, flat rock and pounded and ground until reduced to dust. Discarded manos and metates were often used for this purpose. Any foreign material was removed during this process. When reduced to an even texture, the clay was placed in a container, water poured over it and it was allowed to soak over night.

Guthe (1925:19) described the process for San Ildefonso:

One method of cleaning clay may be used either at the beds or at home. The material is winnowed like wheat to remove small pebbles and fine gravel either of which will ruin a vessel. The large impurities are, of course, picked out by hand. . . . Another variation is to toss the clay into the air from a shallow basket. The movement is repeated quickly and rhythmically; the wind as before blowing the fine stuff on the shawl, while the coarse particles fall back into the basket. After this tossing has been repeated a dozen or more times, the residue, which consists mostly of coarse impurities, is thrown away. . . . If at the time of gathering the wind is not strong enough for winnowing, the uncleaned clay is brought to the house. Here it may be kept for a windy day, or may at once be sifted through an ordinary kitchen sieve of medium large mesh.

Gathering and Preparing the Filler

The filler, or tempering agent, is a volcanic tuff that is mixed with the body clay to permit more uniform drying. The qualities the potters look for in the filler are fine texture, accessible pits, and ease of removal from the quarry. Variation in color is not important. The potters are fully aware of the reason for adding a nonplastic agent. Shepard explains the purpose of temper:

Temper has sometimes been referred to in archaeological literature as a binder which has the effect of strengthening the body. Actually, the plastic clay is the binder and nonplastics weaken the body. Temper is used despite this disadvantage because it counteracts shrinkage and facilitates uniform drying, thus reducing strain and lessening the risk of cracking. The effect is easily understood. Each of the fine particles of a plastic clay is surrounded by a water film. As water at the surface is drawn off by evaporation, it is replaced by water from the interior, but the movement is slow because of the fineness of capillary spaces between particles. Consequently, the outer zone may become much drier than the inner zone, and strains are set up because of differences in rates of shrinkage. The nonplastic matter, being coarser than the clay, opens the texture and allows water to escape more readily. It also reduces the amount of water required to bring the paste to a workable state. When a clay is highly plastic, temper renders it less sticky and easier to work, but an excess will reduce plasticity to the point at which the clay is lean or short and lacks the cohesiveness necessary for shaping. Firing shrinkage occurs when clay particles draw together as they soften and sinter. Nonplastics, being coarser, decrease the effect (1965:25).

The prehistoric and historic pottery of the Santa Clara region shows a continuous use of fine, soft volcanic tuff since A.D. 1200 (for example, Santa Fe Black/White). This is still the only agent used as temper. Deposits are visible as white strata at the rims of most of the hills in the area.

In 1968, access to the Pojoaque sand quarries, which had been used by the Santa Clara Indians since 1928, had been denied the Santa Clara potters as a result of a feud between the two pueblos. According to a note found with a polished black bowl in the Denver Art Museum, this deposit had come into use in the following way:

> In 1928, my sister and her husband and I tried the blue sand from the hills near Pojoaque. We had seen how smooth

Maria's pottery was and we wanted ours to be like hers. So we looked for fine sand. Other people tried and their pottery broke in firing. But now they use coarse and fine sand together. We used to ask permission from the Pojoaque Governor and we gave them a dollar. They told us we could take all we needed. Juan Tapia used to be the Governor when they first gave us permission [name of the informant unknown] (Catalogue Card Number XSC-97-G).

Prior to 1928 and within the memory of the potters, a large tuff deposit near Hernandez was quarried; this collapsed around 1926 from having been dug too deep.

The potters in 1968 were trying volcanic tuff from different areas and finding it difficult to regulate the mixture of tuff and clay. Two deposits were being tested, one near Highway 76 and the other across Highway 64–84 from a formation known as Camel Rock. One informant believed that the first deposit, located on the crest of a hill, was too firmly packed and difficult to loosen, and that it would take a great deal of work to pound or mash this tuff in preparation to mixing it with the body clay. The second area, preferred by most of the potters, is much more accessible, and the tuff more closely resembles that from Pojoaque. By the end of the summer of 1968, the potters had regulated the mixture of clay to tuff, and the problem had been solved.

The tuff is scraped loose as a fine powder from the quarry with a sharp, pointed instrument (Fig. 5). It is not treated at the quarry but is taken home and kept dry until ready for use. Then it is sifted through a very fine mesh screen. One sieve constructed for this purpose was a wooden frame 4 inches high, 12 inches long, and 18 inches wide. The tuff is first stirred by hand, then poured through the mesh and sifted with a back-and-forth motion over a container. This tempering agent, unlike the clay, is stirred and pressed through the sieve, leaving a residue that is thrown away. A calm, windless day is essential for this process; the particles are a fine powder (Fig. 6).

Hill's field notes are at variance with mine. According to him:

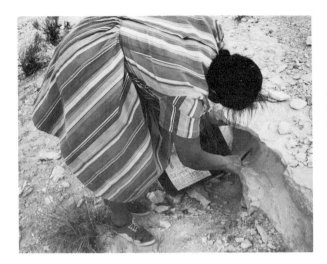

Figure 5. Removing the tuff from the quarry (Helen Shupla)

Figure 6. Sifting the tuff (Helen Shupla)

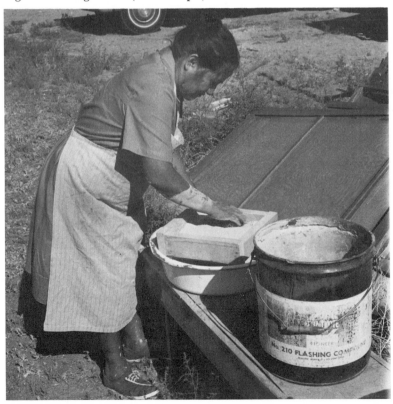

The tempering material was placed in a sack and pounded. After pounding it was screened to insure a uniform consistency. Before the introduction of modern sieves, horse hair ones were used. They consisted of a split oak circular frame and a horse hair mesh (1940).

Jeançon noted:

> . . . A fine grained sand is gathered from the banks of the Rio Grande and Chama Rivers, as well as from the stream beds of the larger creeks close to the villages. . . . The very fine, white sand, rich in silicate grains, is freed from foreign matter by washing in a basket. After cleansing it is thrown onto cloths to dry. When dry it is sifted until each grain is separated from the others and then stored until needed (Douglas 1931:1).

Mixing the Clay and Filler

The body clay and the volcanic tuff are mixed on a large piece of canvas that has been moistened to prevent the clay from sticking. In spite of some water evaporation, the clay is still a thick, muddy consistency. Mixing is done on the floor inside the house. Most of the potters prefer to have the men mix the clay, as it is hard, tiring work, especially when large quantities are being prepared. The tuff is first poured on the damp canvas; clay is added by handfuls. The potter does not measure either ingredient. Helen Shupla said that one learns the proper consistency the hard way: "When it starts drying and cracks, you know you don't have enough sand in the clay. Then you put the pots back in the wet clay, melt them down again and add more sand" (Fig. 7).

The potter, on hands and knees and supporting herself with one hand, adds clay from the mound. Initially this mass is kneaded like bread dough (Fig. 8). The color is not uniform; streaks of the white tuff are still visible. Next the potter changes her position and rests on both knees, while she lifts the edge of

17

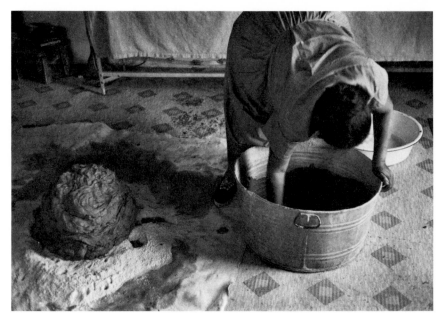

Figure 7. Adding the clay to the tuff (Helen Shupla)

Figure 8. Kneading the clay and the tuff (Helen Shupla)

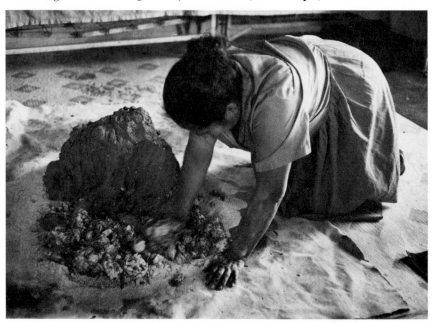

the canvas to roll the tuff from the bottom onto the top of the clay. She rubs the clay and tuff back and forth with the heels of her hands. When the ingredients are combined by this kneading, the potter uses her feet. She walks around the mass stepping first on the edge, then into the center, mashing and stepping. She pushes the clay from the outside toward the center with the outside of her foot, picks up tuff on her wet foot, and pushes it into the clay. At intervals she lifts the corner of the canvas and rolls the mass over on itself, bringing the bottom to the top. This procedure continues until the color becomes more and more consistent, with the parts of tuff indistinguishable from the clay itself (Fig. 9). This blending lightens the color of the clay. If the mass is too wet, it is spread out to dry until it is the proper consistency for modeling. Occasionally an electric fan is used to increase the rate of evaporation. The residue from sanding vessels, which is saved, is also added to the clay at this point to absorb some of the excess moisture. At intervals between rolling

Figure 9. Mixing clay and tuff with the feet (Helen Shupla)

the canvas and kneading with the feet, the potter tests the mixture between her fingers to see if it has dried sufficiently for use. Helen Shupla said, "It is supposed to feel like putty when it is ready to mold."

After an hour of kneading, the mixture reaches the desired consistency and is pulled to the corner of the room. Two or three hours later the clay is transferred to a large cotton cloth and covered tightly with plastic film to prevent further drying. (The outside temperature at the time of this study was in the 90s and water evaporated from the clay rapidly.)

Jeançon's observations of this step in 1906 were as follows:

> The potter mixes two parts of clay to one part of sand, in a dry state, on a cloth with her hands. This is to insure the materials being thoroughly and properly mixed. Then water is flipped over the mass until it becomes fairly moist. It is then kneaded, patted, and rolled. Finally if not moist enough, it is again spread out on the cloth and more water added. When the mixing is finished the paste is rolled into a ball and wrapped in a damp piece of common canvas. . . . The mixing is a delicate operation for should there be too much clay the vessel will crack in baking or be too porous. Too much sand will make it crack and crumble after baking. Also the paste must have neither too much nor too little moisture. If too wet it will collapse during the drying, while if not wet enough it will be too crumbly and not stand up (Douglas 1931:1).

Hill observed in 1940:

> The following morning the soaked clay was placed on the inside of a sheep skin or cloth, dry tempering material added, and the two kneaded together with the fingers and the palms of the hands. The amount of tempering was not measured. The potter knew from experience when the clay had reached the right consistency. Since the introduction of Pojoaque temper, coils have been made from clay about the

consistency of heavy cake batter. When large amounts of clay were prepared it was kneaded with the feet. Recently men have performed this operation. Again experience determined the amount of the clay prepared. They knew the approximate quantity needed to produce a given number of pots. Any surplus was stored for future use.

Guthe (1925:20) reported that at San Ildefonso the clay and tuff were mixed dry, then water was sprinkled over the mass and it was kneaded until the water was thoroughly absorbed. The paste was divided into portions and kneaded like bread dough with the hands until a uniform consistency was achieved.

Sources and Preparation of Slips and Paints

A slip is a thin suspension of water and clay particles applied to the surface of a vessel to improve surface color and texture. It also renders the vessel less permeable, especially after the surface has been burnished, since it fills the pores with a finer material. Two kinds of slips are used at Santa Clara, one for the Polished Black ware and one for the Red Polychrome ware.

The slip for the Polished Black ware is 60 percent clay, 5 percent hematite, and 30 percent quartz, with the remaining 5 percent undifferentiated. The color of the slip on the Munsell Soil Color Chart before firing is 10R 5/4. This slip is purchased from the Santo Domingo Indians, who deliver it to the potter's door. It is gathered by the Santo Domingos on their reservation.

The red slip (10R 4/6) is also purchased from the Santo Domingos. It is 40 percent hematite, 40 percent quartz, and 15 percent clay, with the remaining 5 percent undifferentiated.

The raw material—small lumps of clay—is stored until ready for use. Then the lumps are put in a container and water is added. The clay is pure enough so that as soon as the lumps dissolve it is ready for use. The suspension is the consistency of a

thin cream. The larger particles settle to the bottom of the container. Only the clay in the water suspension is applied to the vessel. The water is stirred frequently to keep the solution "saturated." Shepard describes this "saturated" solution:

> . . . This slip has been described as a "saturated solution" of clay in water, but the term refers properly to the concentration of a substance that is soluble. Since the clay slips are in suspension, the term "saturated" can be understood to refer to the maximum amount of clay that will be held in suspension (1965:68). . . .

All the paints at Santa Clara are earth colors mixed with water. The colors are yellow or buff, red, white, gray, and the matte black on the Polished Black ware.

The yellow paint is gathered to the east of Highway 85 near La Bajada (between Albuquerque and Santa Fe). It is shown by X-ray diffraction to be 10 percent quartz and 85 percent clay (which is 5 percent kaolin, 10 percent mica, and 60 percent montmorillonite mixed layer). The potters gather this clay paint as they do the body clay.

The red paint for the Red Polychrome is the same clay used for the slip and paint on the Polished Black ware.

White paint is always used for outlining designs. It is 25 percent kaolin, 40 percent mixed layer, and 30 percent quartz, with the remaining 5 percent undifferentiated. It is white in the raw state and fires white. According to Shepard, "The majority of white paints were relatively pure kaolins or white marls—a mixture of clay and calcite. The kaolins are usually powdery after firing because they are much more refractory than the body" (1965:43). This clay is gathered by the potters near Dulce (more than 100 miles distant); the exact location was never divulged.

The gray paint, the source of which was not disclosed, is a very light gray clay before firing, but it is mixed with pure white to produce a gray-blue color after firing. The X-ray diffraction shows 95 percent montmorillonite, probably not mixed layer, and 5 percent quartz. Because of the oxidizing character of this

particular paint, which turns from a very light gray to black when fired, a spectrographic analysis was run on this sample of clay. Elements present, by percentage, were: iron, 2 percent; magnesium, 3 percent; calcium, 15 percent; titanium, .07 percent; aluminum, 10 percent; silicon, greater than 10 percent; sodium, 1 percent. Trace elements present, by parts per million, were: manganese, 15; boron, 30; barium, 200; strontium, 150; zirconium, 150; gerium, 150; and neodymium, 70.

The clay used for painting the matte designs on the Polished Black ware is the same as that used for slipping the black vessels.

All the clays used for painting are prepared in the same way. Small lumps of clay are placed in a shallow vessel such as a saucer. Water is added and the clay is soaked and stirred to dissolve the lumps. A nylon stocking or a cloth of any porous material is laid on top of this solution to ensure that only the fine particles of clay in the thin suspension will be applied. Lumps or small pebbles destroy the designs. The paints are saved in their containers; when they have dried out, more water is added and the suspension can be used again.

In 1940 when Hill did his fieldwork, the paint for the blackware was derived from beeweed (*guaco*). He describes the process as follows:

> The paints were boiled until concentrated, "almost carbonized." "They were boiled until they reached the consistency of molasses, run through a sieve, and worked into a brick with the hands. This hardened like clay" (informant). When needed, a piece was broken off and mixed with water. After firing the design element emerged in dull greyish-black on a lustrous black background. Paint was allowed to dry for an hour to an hour and a half before firing.

Guthe (1925:25) observed the same process at San Ildefonso in 1921. By 1968 the only paint used at Santa Clara was clay without additive. The informants had a vague memory of potters painting with beeweed, but none could remember making or using it themselves.

Modeling the Vessel

For modeling the potters use molding spoons (*kajapes*) and other shaping tools, scraping tools, a mold (*puki*) for holding the base of the vessel, water, and a lap board.

Guthe (1925:27) described the molding spoons at San Ildefonso in 1921 as being made from pieces of gourd rind, usually from broken rattles or dippers. Kajapes were made by some of the potters in 1968 at Santa Clara by shaping coconut shells. Most of the potters interviewed said gourds absorb too much water and don't retain their shape. The men cut coconut spoons from the shell and shape them into round, oblong, or triangular forms. The size varies according to the preference of the potter, but most of these spoons fall between 2 inches and 3½ inches in circumference. Another shaping tool is a simple tongue depressor. Some of these have been in use so long that both edges are worn in toward the center. A ceramicist's tool, a bent wire at the end of a wooden handle, is used for shaping on restricted-rimmed vessels (Fig. 10).

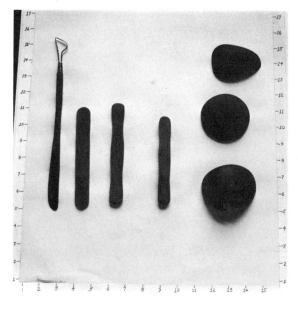

Figure 10. Modeling paraphernalia

A container holding water is always placed within easy reach of the potter. All the tools are kept in this while the potter is modeling the vessel. The potter sits on a chair with a plywood board in her lap. The size of these boards varies; one measured 12 inches by 16 inches.

In shaping most large vessels, the potter places the base on a small wooden board resting on top of the plywood lap board or in a small ceramic bowl or plate used as a mold. She sprinkles the mold with tuff to prevent the wet clay from sticking. Small vessels are simply fashioned by hand without the use of a mold.

Hill reported, "Each potter possessed a set of dish-like base forms. These were of pottery and of varying sizes and shapes to meet the requirements for all the standard pottery types. Those for water jars had welled bottoms. Many of these form sets were old having been passed down within the family for generations" (1940). Those used by one of his informants had belonged to her great-grandmother. I did not find such sets in use in 1968; the most common puki was a porcelain cereal bowl.

All vessels are started in the same manner, except, of course, the animalitos and small flat ashtraylike dishes. The potter takes a lump of clay somewhat larger than her fist and pats it into the shape of a cone. She holds the clay in her left hand and rotates it, slapping it into shape with her right hand. She turns the wide side of this cone toward her right side and with her right fist punches a depression into the center of the clay mass. With the fingers of her right hand she enlarges the opening (Fig. 11). She lays the base on the lap board with the depression up. She takes the shaping spoon or kajape from the water and holds it in her right hand, while she supports the exterior of the base with her left. The strokes of the kajape are parallel to the rim. The potter scrapes and thins the walls starting at the bottom of the base. As she finishes one area of the vessel, she lifts the clay and repeats the process until the interior of the base is shaped. She then turns the clay upside down and, using the wooden stick in diagonal strokes from the rim to the base, removes small amounts of clay and smooths the exterior of the vessel. She picks up and rotates the vessel until the entire surface is smoothed.

The potter keeps the smoothing stick moist by dipping it in the water basin. She lifts the base of the pot and holds it in her left hand while she again shapes and smooths the bottom. She rotates the pot by gently throwing it 2 inches from the hand and catching it in one-twelfth of a turn on its axis, repeating the diagonal smoothing strokes from the base upward to the rim. The base is formed and at this point is placed in the mold or puki, which has been sprinkled with the sand (Fig. 12).

Figure 11. Enlarging the depression for the base (Helen Shupla)

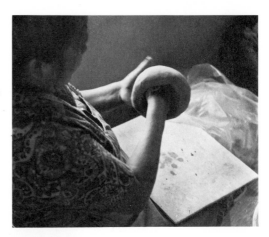

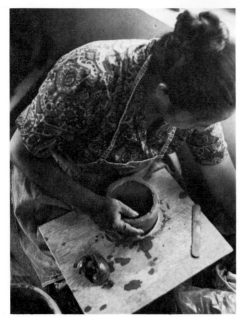

Figure 12. The base inside the puki (Helen Shupla)

The potter builds a vessel from this base by the successive addition of rolls of clay. A roll of clay is called a coil in many references, which suggests a spiral placement of the rolls. Although this suggestion is misleading, Shepard (1965:57) feels that the term "coiling" for this type of pottery construction is appropriate as it has been established by common usage.

The potter forms a coil by holding a mass of clay in both hands and rolling it back and forth between her palms. She works the clay from the center to the end, then turns the roll, grasping it in the center again, spinning and rotating it until she has formed a coil 3/4 inch to 1½ inches in diameter and long enough to completely encircle the vessel. She presses this roll on the interior of the base, with her thumb in the interior and four fingers on the exterior. Her left hand, held 4 inches above the vessel, supports and feeds the coil. She turns the vessel with her right hand until the entire coil is pressed on the inside of the base. It is amazing to see how consistently accurate the potters are at gauging the amount of clay necessary to encircle the inside of the base. If their judgment falls short, whatever amount is needed to complete the circle is added (Figs. 13 and 14).

In modeling small vessels one coil is sufficient, but for larger bowls such as wedding jars and long-necked jars more than one coil is needed to form the body or neck. A second roll is pinched directly on top of the first before smoothing both coils.

The first step in smoothing and thinning the walls after building them up with the coils is to use the kajape on the interior. The potter holds her left hand firmly on the exterior of the vessel and with the kajape in her right hand forces the clay into the desired shape, moving the kajape parallel to the base in approximately 3-inch strokes. The exterior often shows stress cracks from the pressure. She rotates the bowl in a clockwise movement as she pulls and shapes the walls.

The potter then uses the tongue depressor on the exterior in diagonal strokes from the top of the puki to the rim of the vessel. With her left hand on the interior of the vessel, she rotates and shapes the exterior walls with her right. During the process she dips the tongue depressor in the water basin frequently to keep

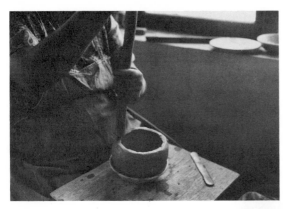

Figure 13. Forming the first coil

Figure 14. Adding the coil to the base

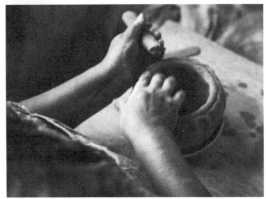

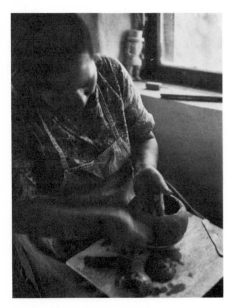

Figure 15. Obliterating the coils with the kajape (Helen Shupla)

the exterior moist. She removes the stress cracks by redistributing the clay particles and filling the areas with bits of clay. She scrapes small amounts of clay onto the stick as she thins the walls, then removes these with her index finger and thumb. She scrapes the clay removed in this fashion onto the lap board and uses it when a filler is needed (Fig. 15).

By this point in the process, the potter has made a restricted-rimmed, globular vessel. This basic shape can be altered to include square-sided vessels, unrestricted-rimmed bowls, long-necked jars, and double-spouted vessels.

Large Unrestricted-rimmed Bowls

After the potter has obliterated the junction at the base and the coils, she smooths the interior and exterior walls, turns the vessel upside down, and smooths the base with the tongue depressor. Then she places the vessel on a large flat ceramic plate.

The potter forms a third coil and presses it inside with her thumb on the exterior and four fingers of her left hand on the interior. She rotates the plate as she secures the coil to the vessel. Next a fourth coil is pinched to the top of the third coil on the interior of the vessel (Fig. 16). With her left hand holding the exterior of the vessel, the potter scrapes the interior with the kajape in strokes parallel to the rim. Starting at the base and working to the rim in 3-inch strokes, she rotates the vessel until the entire inside is smoothed and the walls are thinned and pushed into the shape of the bowl.

The potter then uses the tongue depressor on the exterior, removing small amounts of clay to further thin the walls and shape the vessel. Because the bowl is 12 inches in diameter, two hands are needed to rotate it. The potter works the interior of the vessel again with the kajape, using strokes diagonal to the rim. Small amounts of clay are removed and saved on the board. The vessel walls are forced outward by this process (Fig. 17).

When the potter has modeled the shape she wants, she

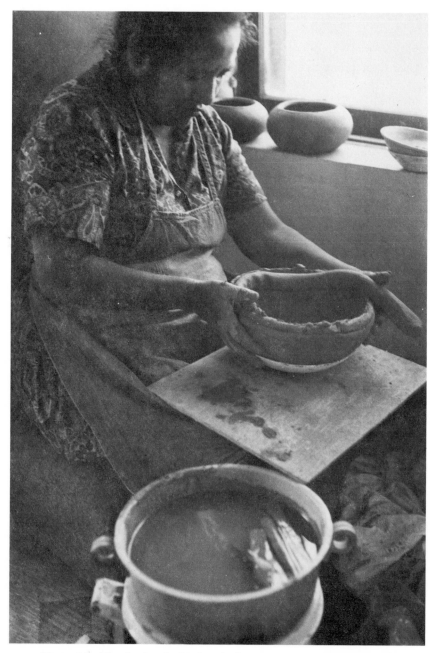

Figure 16. The third coil added to the large bowl (Helen Shupla)

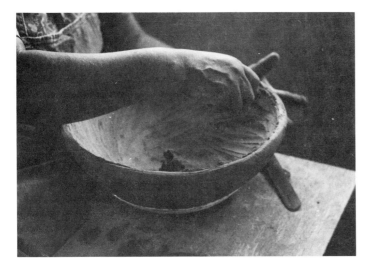

Figure 17. Scraping the interior of the bowl with the kajape

moistens her hands and, with the right index finger and thumb held firmly on the rim, thins and evens it. She rotates the bowl with her left hand, moving the plate mold clockwise. She dampens her fingers frequently and continues rubbing, making sure the rims are of uniform thickness. If an area is too thin, she adds a bit of clay and gently rubs it in. After the rim is leveled, she dampens her right thumb and runs it completely around the rim to further smooth the edge. Again she moistens her hands and smooths the exterior and then the interior of the vessel. This completes the modeling of the vessel.

If twisted handles are to be added, an additional step is necessary. For each handle, the potter forms two short coils 4 inches long and 1 inch thick. She lays them side by side on the lap board and twists them together. She presses two edges on the outside of the rim, with her right hand pressing the clay into the vessel wall. Her left hand supports the other end of the handle until the first end is secured. She then secures the opposite end of the handle on the exterior wall. She rubs, smooths, and shapes the end of the double coils until they blend into the wall of the vessel. When the coils are attached in this manner, a round hole remains, separating the handle from the rim in the center. The

potter smooths and works this area, moistening her index finger frequently (Fig. 18).

When both handles have been attached, the potter dips both hands in the water and rubs the interior with her right hand while supporting the exterior with her left. She rotates and smooths the vessel, removing any marks or scratches left by the tools. It is then set aside to dry before being removed from the puki.

The vessel just described was 12 inches in diameter and 5 inches high and took the following time to make:

Element	Time
Base	1 min. 12 sec.
First coil	1 min. 8 sec.
Second coil	3 min. 13 sec.
Third coil	5 min. 40 sec.
Rim	6 min. 58 sec.
Handles	9 min. 34 sec.
Finishing	9 min. 15 sec.
Total elapsed time	37 min.

Long-necked Jars

The potter makes the base as has been described previously, round with a restricted opening. She forms the first coil and places it on the exterior of the vessel by holding it in her right hand. With her left hand, the thumb on the outside and the fingers on the inside, she pinches the coil to the body. Second and third coils are added in the same way, overlapping the first on the exterior rather than the interior, as was done in forming the base (Fig. 19). The potter smooths the coils by using the kajape on the outside, in strokes diagonal to the shoulder, from the shoulder to the rim. Her left hand supports the interior wall while her right pulls the clay to the rim (Fig. 20). After smoothing the exterior surface, the potter smooths the interior with the tongue depressor, supporting the exterior wall with her

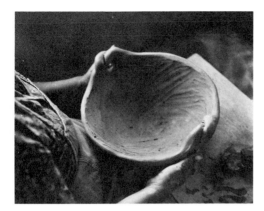

Figure 18. The large bowl before smoothing

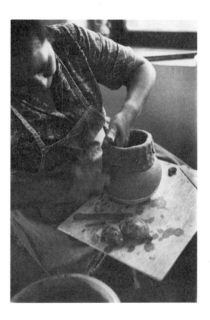

Figure 19. The third coil placed on the exterior of the base (Helen Shupla)

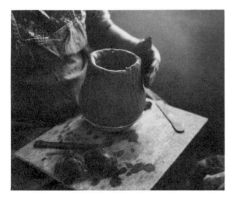

Figure 20. Obliterating the coils

left hand while her right scrapes and evens the interior wall. Her strokes are parallel to the rim and approximately 3 inches long, and she rotates the pot as she works an area. After the preliminary thinning she again wets the stick and scrapes the exterior walls with diagonal strokes starting at the shoulder and pulling toward the rim (Fig. 21).

When the potter has achieved the length and the shape of neck she prefers, she moistens her hands and forms and smooths the shoulder, supporting the neck with her left hand on the interior. Her right hand rotates the vessel and also smooths the

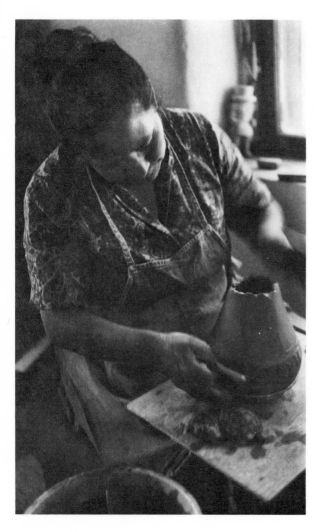

Figure 21. Scraping the exterior of the jar (Helen Shupla)

area between the neck and body. She adds small bits of clay to the areas she feels are too thin, pressing them into the surface and rubbing them in with her damp fingers in a back-and-forth motion.

The rim is then finished and the vessel, if it is to be left undecorated, is set aside to dry.

The Double-necked Jar or "Wedding Vase"

After modeling the body, the potter forms a coil, flattens it slightly, and presses it on either side of the rim in the center of the vessel, forming a bridge. She supports this as she fills in the attached area with small bits of clay, then smooths the bridge with the kajape (Fig. 22).

Next she forms another coil and places it on the exterior of one of the orifices formed by the bridge. She holds this coil in her left hand while her right thumb presses it together in a spiral, using only the one coil to form the neck (Fig. 23). After it has

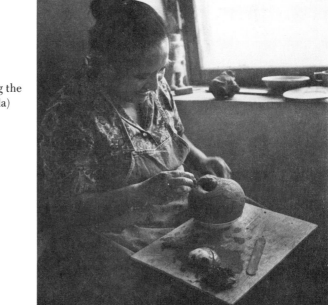

Figure 22. Forming the bridge (Helen Shupla)

been attached she smooths the coil on the exterior in downward strokes from the rim to the shoulder of the vessel. The spiral for the second spout is formed and attached in the same way. The potter smooths the interior walls of both spouts with a long wooden tool, shaped like a kitchen knife, which reaches as far down as the shoulder where the spouts are attached to the body. Then she smooths and thins the exterior walls again with the kajape in strokes perpendicular to the rim. She evens the rims on both spouts by removing or adding clay.

For a handle the potter attaches a short coil to the inside of one spout and then the other, smoothing and shaping it to the neck with the fingers and thumb of her right hand while her left hand supports the handle (Fig. 24). After the handle has been attached, she adds a piece of clay to the outside of each neck, forcing it downward and into the shape of a spout.

The potter again levels and straightens the rims of both spouts by either adding or pinching off small bits of clay. She holds the long tool on the inside, rotating it in a circular movement to even and round the walls of the neck.

Dipping her hands in the water, the potter smooths the

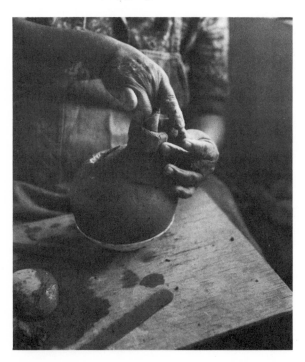

Figure 23. Attaching the spiral coil for the neck

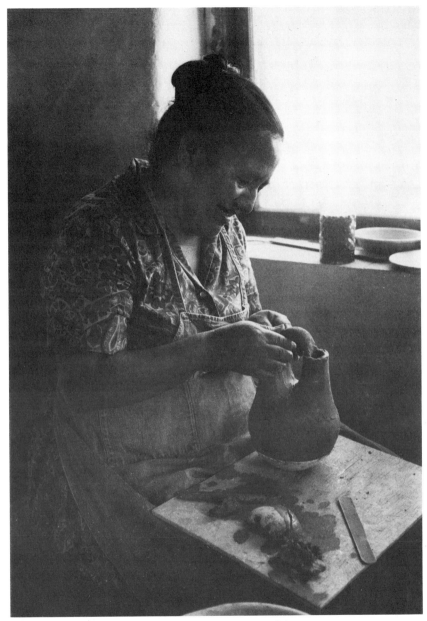

Figure 24. Attaching the stirrup handle (Helen Shupla)

outside of the walls again, rubbing with either her index finger or her thumb. Areas that are too thin and uneven she fills with small pieces of clay, forcing them into the body with a back-and-forth motion. Again she dips the wooden stick in the water and scrapes the body from the puki to the shoulder, evening and smoothing the exterior walls. She dips the fingers of her right hand in the water and rubs the vessel in downward strokes to further smooth the surface and eliminate any marks left by the scraping tools. This last smoothing distributes the clay particles and leaves the surface pasty.

After a vessel has been modeled and smoothed, it is allowed to cure until it reaches the leather-hard stage. When the pot has reached this stage, the potter dips the tongue depressor in water and scrapes the body to further thin and even the walls. She lifts the vessel from the puki and removes the mark left by it with the tongue depressor. The potter holds the vessel next to her body, supported by her left hand, with the neck of the vessel toward her left arm. She pulls the scraper across the vessel toward her body in strokes parallel to the rim, working from the shoulder toward the base. Again she moistens her fingers and gently rubs the pot to eliminate any marks left by the scraping tool. If the vessel is to be carved, it is placed in a plastic bag until it can be decorated. Many of the men in the village do carving and painting but leave the modeling to the women. Some of the men also assist in slipping and polishing.

Sanding and Smoothing

After the vessels are completely dry—about two days, depending on their size and the weather—they are sanded with first a coarse sandpaper and then a very fine sandpaper. The residue is saved and added to clay for later pieces as it is mixed with the tempering agent (see p. 20). Sanding accomplishes two purposes: The first sanding thins the walls, and the finer sanding removes any gouges or lines and further reduces the walls. This step may be done outside the house, as it creates so much dust, although

some potters do sand in their homes and catch the residue in a large container.

Jeançon relates that the vessels were scraped with an old knife or a bit of glass or rubbed down with coarse sandpaper (Douglas 1931:2). Hill (1940) says that formerly a piece of bone or sharp stone was used to smooth the surface.

After it has been sanded, a pot is smoothed again by applying water to the entire surface with a cloth. The potter dampens and rubs with the cloth until the surface particles are redistributed and scratches made by the last sanding are filled. The vessel becomes very smooth and uniform in texture (Fig. 25). Carved vessels are treated somewhat differently (see "Decorating," p. 46).

During smoothing, the potter supports the vessel with her left hand, with the vessel resting in her lap. The base of the vessel faces her right side and its orifice is toward her left side. She rubs the vessel with a wet rag folded into a 3-inch-wide mop, rotating the pot as necessary and continually moistening the rag in the water basin next to her. After finishing the bottom portion, the

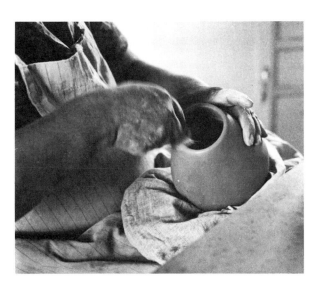

Figure 25. Smoothing the vessel with mop and water

39

potter turns the vessel so that the orifice is toward her right, and continues mopping until the exterior of the vessel has a pasty, smooth appearance. The rim is treated by dipping and rubbing the cloth on the edge, taking care to round the edges. The potter also uses her damp fingers to help smooth the vessel.

Slipping and Polishing

The potters at Santa Clara employ the same methods for slipping as described by Guthe at San Ildefonso in 1921 (1925:57). The materials and equipment needed for slipping and polishing include the water clay solution in a container, mopping cloths, and polishing stones (Fig. 26). The water clay solution is kept in an open-mouthed vessel and is applied with either a cloth folded to 1½ inches to 2 inches wide or a paintbrush of a similar width. Polishing stones are highly valued and many are heirlooms. Most are gathered at riverbeds, but many have recently been purchased at lapidary stores. They vary in size and shape, depending on their uses, from 1 inch to 2 inches in diameter. Each potter has her favorite stone, which becomes highly polished from use.

The red slip for Red Polychrome pottery and the slip for the Polished Black wares are applied and polished in the same way. Some men help their wives polish pottery, but most of the men interviewed did not like this chore.

The first step is to cover the entire vessel with an application of slip. The potter supports the vessel with her left hand inside the pot and paints it from the base to the rim, rotating it to cover the entire surface. She covers the rim and neck, laying the pot in her lap. Then she waits to see "how fast it dries": "If it dries too fast I have to put some more on" (informant) (Fig. 27).

The potter applies another coat, starting at the base and slipping to the rim. She can judge from experience how much slip is necessary; this varies with the outside temperature and weather. Usually two applications are made. The vessel is always covered completely, and overlapping is almost always necessary.

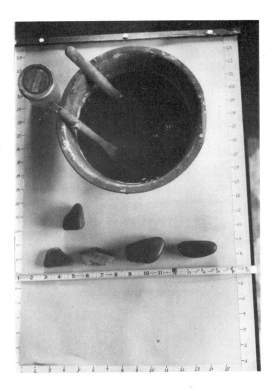

Figure 26. Slipping
paraphernalia

Figure 27. Applying the slip

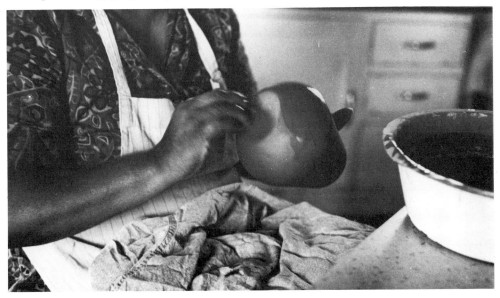

After the pot is sufficiently dampened with the slip and the color is uniform, the potter begins rubbing with the polishing stone (Fig. 28).

> Polishing is a difficult and exacting task. Every inch of the slipped surface must be rubbed again and again with the polishing stone. . . . The potter knows that the slip must be even and the vessel well polished in order that the decoration may be smoothly applied. Polished red or black ware achieves much of its beauty through skillful polishing (Lambert 1966:17).

The first strokes are rather haphazard and the potter quickly covers the entire vessel without polishing it completely. She holds the vessel in her lap, supported by her left hand, gripping the polishing stone between the thumb and first two fingers of her right hand. This initial rubbing appears to assure the potter that the slip is ready for polishing—not too dry, too wet, or too thin. Next she uses another stone and, applying pressure, begins

Figure 28. Polishing the vessel with the polishing stone

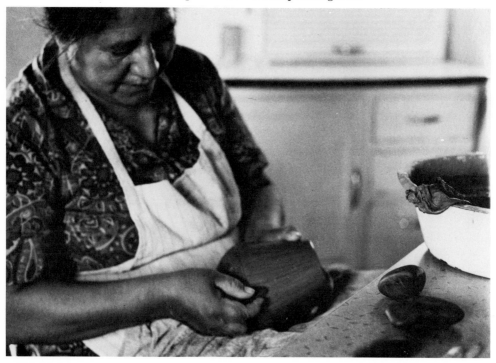

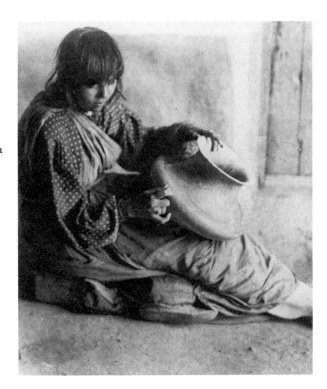

Figure 29. Polishing a vessel (Curtis 1926)

rubbing from base to shoulder in parallel, overlapping strokes 3 inches to 6 inches long. Precision and patience are demanded, since these strokes must be exact and even. The potter rotates the vessel with her left hand until the entire base has been polished. Then she holds the pot with the rim slanted on an angle away from her right side, her thumb on the exterior and fingers on the interior supporting the pot, and rubs in vertical strokes from rim to shoulder. A stone much longer and thinner than the body stone is used for polishing the edge and interior of the rim. Many potters complain that the constant pressure they must exert causes their arms to ache.

Figure 29 is a photograph taken by Curtis (copyright 1905), which shows a potter polishing a vessel. The caption under the picture reads: "Smooth pebbles used for this purpose are found in small heaps among or near deposits of fossil bones. They are the stomach pebbles of dinosaurs. Tewa women prize them

highly, refuse to part with them, and foresee ill luck if one is lost" (Curtis 1926:Photograph 602).

When the entire vessel has been burnished, the potter applies a thin coat of grease or oil with her hands. Most potters prefer turkey or chicken grease, but lard or any other grease can be used. The vessel is set aside for about five minutes until the grease has been absorbed. The explanation given for this application is that it makes the pottery shine more. (It is interesting to note that ceramic companies also apply grease after slipping, which holds the slip to the body clay to prevent rapid drying; in essence it is an organic glue.) Shepard says: "Shrinkage is a primary concern in the production of a polished surface. The effect of contraction after polishing is obvious. Even though the accompanying buckling or wrinkling is on such a minute scale that it cannot be detected visually, it will have the effect of diffusing light and destroying specular reflections" (1965:123). It is apparent that the potters have discovered the usefulness of adding an agent that will increase the luster on their vessels by decreasing the drying shrinkage.

After the grease has been absorbed, the potter repeats the polishing as before. At San Ildefonso, Guthe (1925:64) observed a potter using a chamois rather than a polishing stone after applying grease.

When polishing is completed, the vessel is wrapped in newspaper and stored until enough vessels are ready for firing. It is important to prevent water or perspiration from getting on the polished surface; this will leave a spot that cannot be removed unless the slip is completely sanded from the surface and the process repeated.

Figure 30, a photograph in the Smithsonian Institution (c. 1926), shows the woman at the left polishing a large "dough bowl," the woman in the center scraping a vessel, and the woman at the right demonstrating the use of the large vessel. All of the potters at Santa Clara during the summer of 1968 worked inside their homes rather than outside in the sun. The direct sunlight dries the slipped surface too fast. When the surface becomes too dry the polishing stone scratches the vessel and it has to be sanded before more slip can be applied.

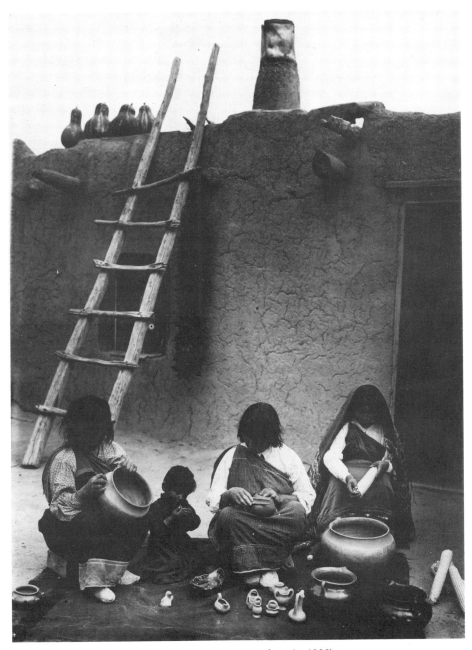

Figure 30. Polishing, sanding, and demonstration of use (c. 1926).
Smithsonian Office of Anthropology

Decorating

There are four methods of decorating pottery at Santa Clara: painting, impressing, carving, and a resist-firing technique with incised, or sgraffito, designs, recently introduced by Camilio Tafoya, Grace Medicine Flower, and Joseph Lonewolf.

Painting in Black Matte on Polished Black Ware

The same clay is used for both the paint and the slip on the Polished Black ware. The color on the Munsell Soil Color Chart is weak red (10R 5/4). Small lumps of clay are placed in a shallow dish and covered with a porous cloth and water; this assures the potter that only the suspension will be used. Any large pieces of sand or other impurities will affect the fineness of design. Guthe (1925:66) says the potters added beeweed as an adhesive, but present-day potters at Santa Clara use only the pure clay.

The artists, both men and women, sit at a table with the receptacle of clay paint within easy reach. The brushes used to apply the paint are common paintbrushes, some of which have been altered by removing bristles from the brush. These are used for outlining and may have as few as five bristles. Other brushes are used for filling in areas, and these vary in width. The collection is placed next to the receptacle of paint (Fig. 31).

The first step in painting is for the potter to examine the vessel and mentally block out an appropriate design. For the Polished Black and the Red Polychrome wares a pencil is never used for drawing in the design, as the graphite is visible after firing.

The potter supports the vessel in the left hand with the fingers on the interior and thumb on the exterior. The vessel rests on the potter's left leg on a cloth. The potter holds the brush between the first two fingers and the thumb of the right hand; the third and fourth fingers steady the hand and hold the brush almost perpendicular to the vessel. Without any support for the right arm, the potter draws straight, even lines freehand. An area of

Figure 31. Paraphernalia for painting

design is marked off on a bowl by painting lines encircling both the rim and the shoulder. The major divisions of the field are then executed by dividing the band into separate units. Usually, a line is drawn from the top band to the lower.

After outlining the designs, the potter begins filling in areas that will be matte. None of the watery clay must be allowed to drip on the polished surface, as this will leave a dull spot in firing. If a line is uneven, the potter evens it with the pointed wooden end of the paintbrush. For filling in the areas, a heavier brush is used (Fig. 32). The potter is careful to apply the paint

47

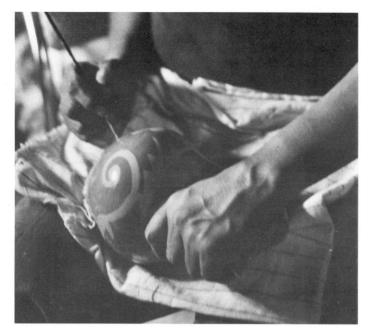

Figure 32. Filling in the solid areas (Kenneth Shupla)

evenly so that the shine from the polished surface underneath will not show through. Of course, the brush is kept full of the suspension by frequent dipping in the paint. Most of the potters I observed used a smaller brush to fill in areas missed after the first application of paint; it is difficult to see all of the small spots that are not covered as the first coat is being applied. It is important not only to cover all the areas but also to make sure that the paint is evenly distributed. A beginning potter has difficulty in achieving this even distribution. When the matte areas have been filled in, some potters go over the outlining again.

Painting on Red Polychrome Ware

Painting on the Red Polychrome ware is performed in the same way as on the matte blackware.

The potter slips the vessel with a hematite clay slip. The slip is applied and polished before applying the paint. The only

difference in this process between this ware and the Polished Black ware is in the color of the slip, which turns to a very dark red in firing. The color on the Munsell Soil Color Chart is 10R 4/6 after firing. The painted blackware uses only one color of paint; the Red Polychrome ware uses four.

The potter applies the design directly to the slipped and polished vessel. Some start outlining in white after examining the vessel and deciding which design will be the most appropriate. Others draw the design on a sheet of paper for reference. One potter used a piece of paper to gauge the distance between the design elements. The entire design is outlined in white with a very fine brush (Fig. 33). Application of this paint is tedious and exacting work. The potter holds the brush like a pen, with the little finger supporting and steadying the hand on the vessel. The brush rides almost perpendicular to the pot, with only a slight tilt toward the hand, and is frequently dipped in the paint solution. After the initial outlining, the potter applies the color inside the outlined areas with a wider brush. Each color dries immediately on application and the area is usually given a second coat directly on the first. Most polychrome vessels contain at least four colors—white, buff, gray, and red. Each

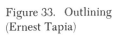
Figure 33. Outlining
(Ernest Tapia)

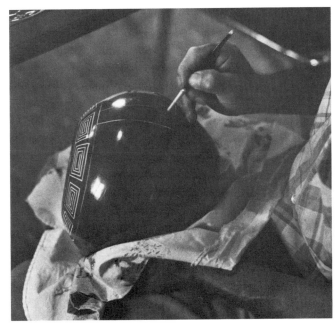

color is completely applied before starting another color (Fig. 34). After filling in the areas, the potter applies a second coat of white outlining directly over the first, using the wooden tip of the brush to straighten or remove any unevenness in the line.

Most of the potters interviewed felt that painting the redware is more tedious than painting the blackware, but they preferred firing the red. Not all potters at Santa Clara make all the different styles. Some prefer to make only the black pottery. The materials used for painting and slipping the Red Polychrome are not as readily available as those used on the Polished Black ware, and this fact probably influences their choice. The potters said they gather the clay colors for paint and experiment with them before using them on the pottery. Where these colors are found

Figure 34. Filling in the solid areas (Ernest Tapia)

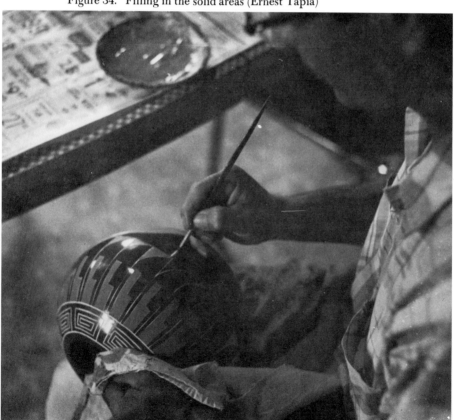

is not always common knowledge, and each potter has to find her own source of clay for the paint.

Lela and Van Gutierrez and their children Margaret and Luther have introduced a pottery style unique at Santa Clara. Their paint and the source of their supply are closely guarded secrets. The catalogue card with one documented vessel in the Denver Art Museum (Catalogue Card Number XSC-27) says that the paint consists of earth colors not used by other potters.

The Gutierrez ware is brick red with painting on a light brown area. The pottery is rubbed with a cloth instead of being polished with a stone, giving the surface a semiglossy finish. The designs are outlined with fine black lines and are mostly anthropomorphic. The areas inside the outlining are filled with either black, green, and dark red or brick red, blue, and white.

Impressing

Probably one of the oldest decorative techniques used on Santa Clara pottery is impressing. Between 1880 and 1930 impressing in diagonal lines, encircling lines, straight lines, and the figure of the bear paw is most typical of Santa Clara vessels. The only designs executed by impressing at the present time are the bear paw and lines to form the melon bowl.

This decorative technique is the least difficult to execute. The only tools necessary are the receptacle of water and the potter's fingers. Immediately after the potter has modeled the vessel, she outlines the shape of her design with her index finger. For the bear paw design, after she has outlined the center line, two on either side, and a semicircle for the base of the paw, she forces her finger into the clay to make the impressions deeper. Then she smooths these lines by moistening her finger and rubbing the impressions. She holds her left hand on the interior supporting the area where she is exerting pressure (Fig. 35).

The melon bowl is a round, restricted-rimmed bowl with impressed lines from the rim to the base.

One informant had been told by her mother that all the large

pieces of pottery had to have a symbol on them to keep the food safe and so the jars would always be full.

Carving

After the pot has been modeled, if it is to be carved, it is placed in a plastic bag so it will not dry. It remains there until it is leather hard and the potter, or carver, is ready to work on it—perhaps as long as a week. Much of the carving is done by men.

The tools used for cutting the clay are X-Acto knives, small pocket knives, and other implements that may have been altered to suit the potter. Tools used for gouging are rounded and dull on the end; one such tool, for example, was a nail, pounded down, flattened, and set in a wooden handle. A pointed beer can opener is used for scraping the areas between double cut lines that are too narrow for a wider gouging tool. The tools vary from 4 inches to 9 inches in length (Fig. 36). A pencil is used to outline the designs on the carved pieces. These designs are usually less detailed than the painted designs.

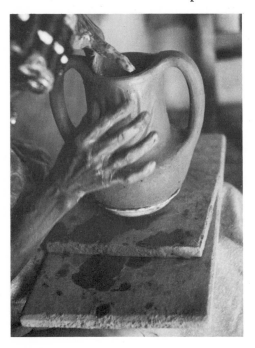

Figure 35. Making the bear paw impression (Flora Naranjo)

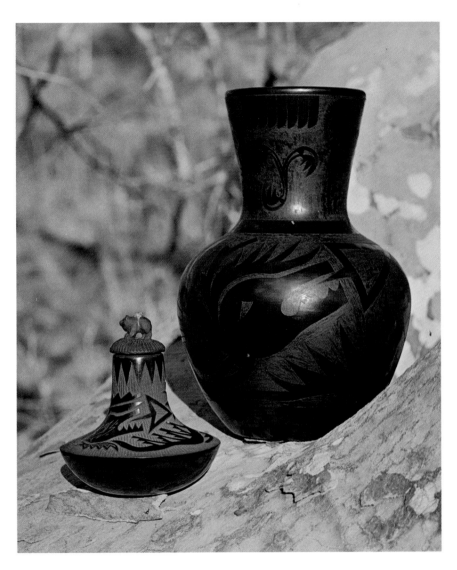

1. Joseph Lonewolf, incised black vessels. Left: Collection of Don and Nita Hoel. Right: Collection of Gene Gordon, Eagle Dancer, Sedona, Arizona. Photo by Peter L. Bloomer.

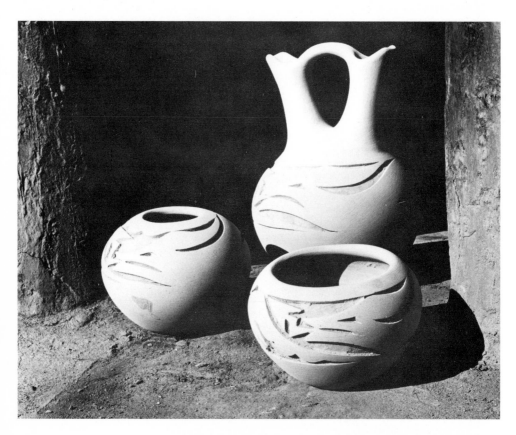

2. Flora Naranjo, modeled and carved pottery, ready to be slipped and polished. Photo by Dick Dunatchik.

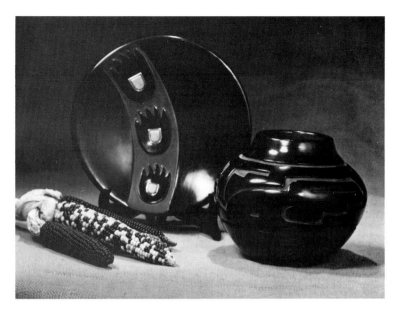

3. Virginia Ebelacker, Polished Black plate
with bear paw designs, turquoise and silver
settings; carved black jar. Photo by
Dan Elliott

4. Camilio Tafoya, carved black bowl, Avanyu
design. Photo by Rick Dillingham.

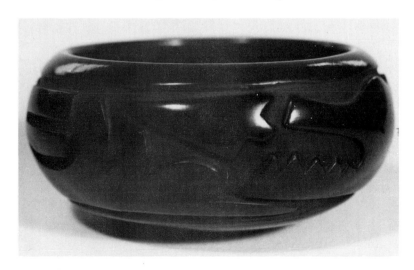

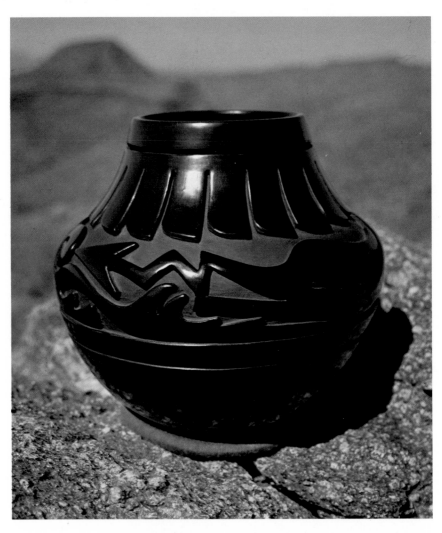

5. Teresita Naranjo, carved black jar, Avanyu design. Photo by Jerry D. Jacka.

6. Helen Shupla, Polished Black wedding vase. Photo by Dick Dunatchik.

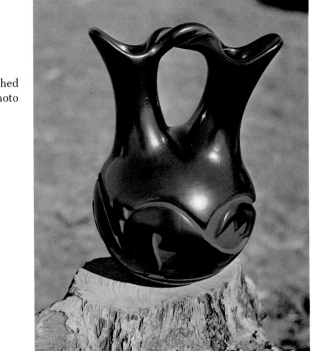

7. Belen Tapia, painted redware. Photo by Dick Dunatchik.

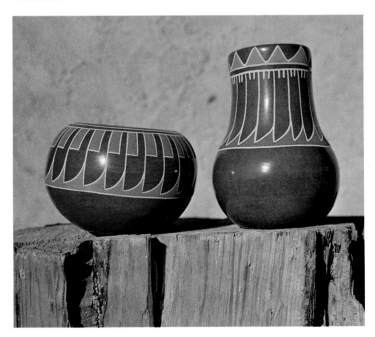

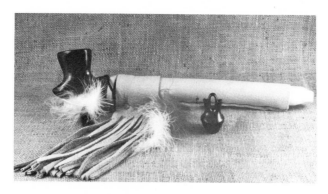

8. Nathan Youngblood, peace pipe;
Nancy Youngblood, miniature
wedding jar, Polished Black sgraffito.
Courtesy of the Maxwell Museum of
Anthropology, University of New
Mexico.

9. Mela Youngblood, Polished Black
jar with bear paw impression.
Courtesy of the Maxwell Museum of
Anthropology, University of New
Mexico.

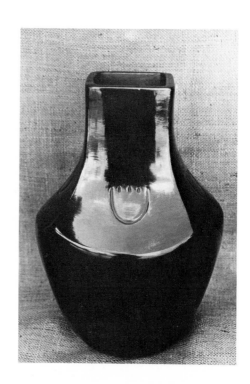

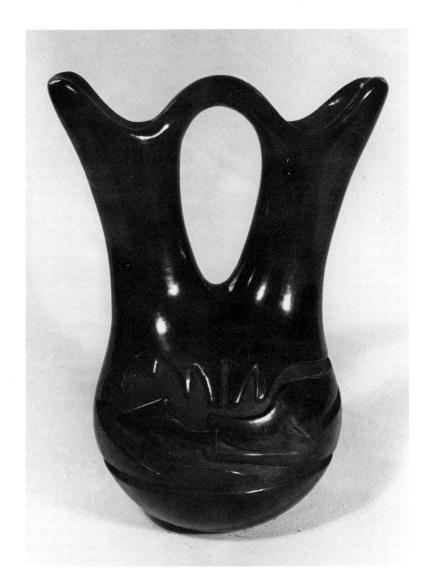

10. Christina Naranjo, Polished Black wedding vase, Avanyu design.
Photo by Rick Dillingham.

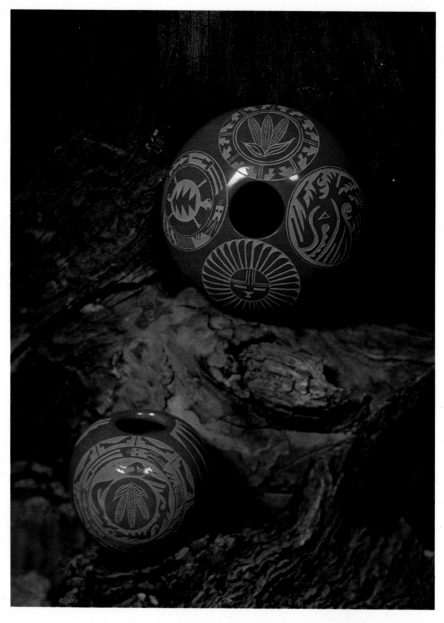

11. Grace Medicine Flower, red sgraffito incised bowls. Tanner's
Indian Arts, Scottsdale, Arizona. Photo by Jerry D. Jacka.

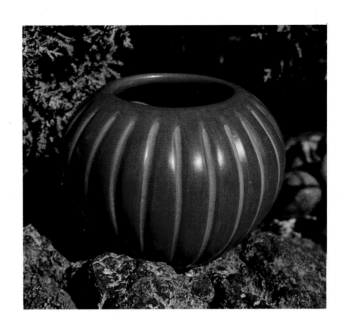

12. Angela Baca, melon bowl. Photo by Jerry D. Jacka.

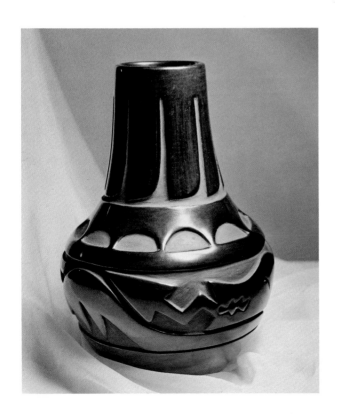

13. Pablita Chevarria, carved black jar, Avanyu design. Photo by Ray Manley.

14. Sarafina Tafoya, Polished Black
storage jar, bear paw impression,
c. 1930. Courtesy of the Maxwell
Museum of Anthropology, University
of New Mexico.

15. Left to right: Clifford Roller,
Polished Black bowl; Toni Roller,
Polished Black jar; Tim Roller,
Polished Black alligator and anteater;
William Roller, Polished Black bowl.
Courtesy of the Maxwell Museum of
Anthropology, University of New
Mexico.

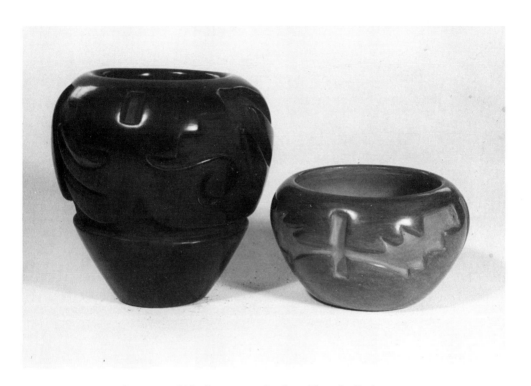

16. Agapita Tafoya, carved black jar; carved red jar. Photo by Rick
Dillingham.

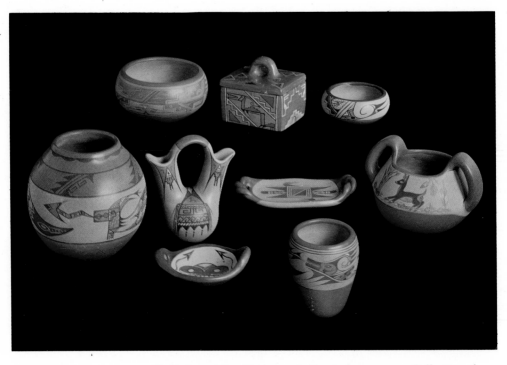

17. Lela and Van Gutierrez, buff polychrome ware. Collection of
Don and Nita Hoel. Photo by Peter L. Bloomer.

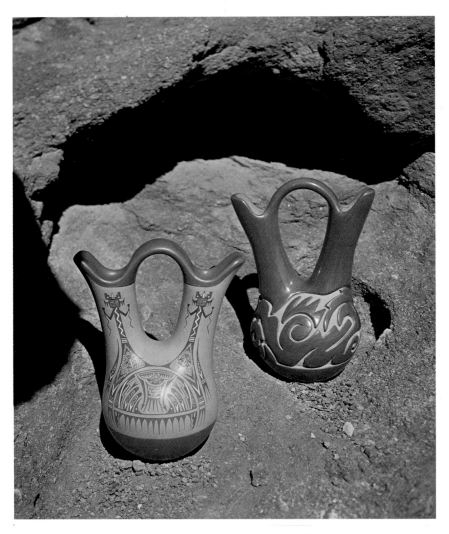

18. Wedding vases. Left: Margaret and Luther Gutierrez, buff polychrome; right: Teresita Naranjo, Polished Red. Photo by Jerry D. Jacka.

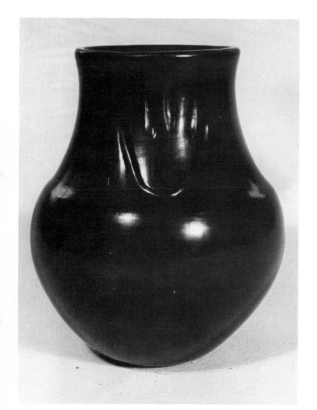

19. Christina Naranjo, Polished
Black jar with bear paw impression.
Photo by Rick Dillingham.

20. Margaret Tafoya, carved
black bowl. Photo by Rick
Dillingham.

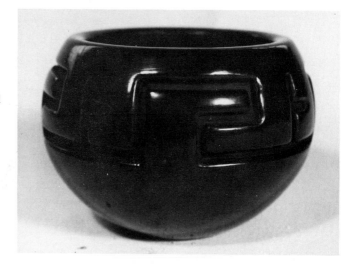

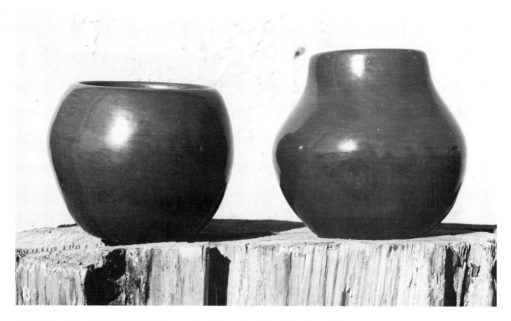

21. Belen Tapia, Polished Red vessels, slipped and polished, ready for painting. Photo by Dick Dunatchik.

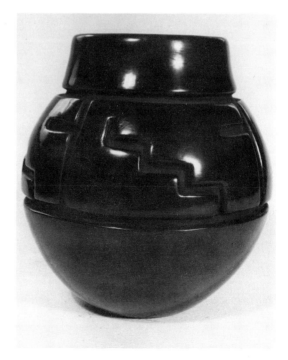

22. Margaret Tafoya, carved black jar. Photo by Rick Dillingham.

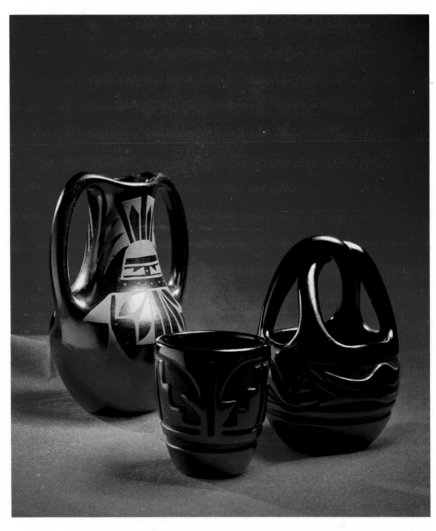

23. Legoria Tafoya. Left to right: Black-on-black jar; carved black bowl; carved black bowl, Avanyu design. Photo by Ray Manley.

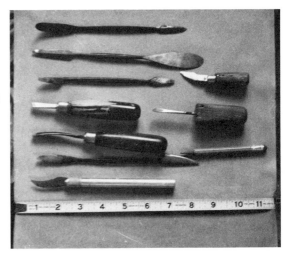

Figure 36. Paraphernalia for carving

The vessel is held in the potter's lap on a cloth. The design is first drawn in pencil, which will not show later because the carving is done before the vessel has been slipped and polished. The potter holds the pencil in the right hand, the little finger steadying the movement. When the design has been laid out, the potter starts carving with a sharp tool. The angle of the cut is toward the area to be gouged out at an angle of about 30 degrees. The potter holds the base of the vessel toward his left side with his left hand supporting it on the exterior, and rotates it to make first the rim and the base lines. Then he outlines the interior design with the sharp tool (Fig. 37), gouges out the clay in the areas between the first cuts, and removes the clay in short scoops about 1/4 inch long. The gouging tool is held by the four fingers of the right hand, with the thumb supporting and steadying the tool against the pot (Fig. 38).

Another tool, shaped like a screwdriver with a flat edge and square sides, is used to straighten the sides of the initial cut from a 30-degree angle to perpendicular (Fig. 39). The center areas where the clay has been removed are also leveled and evened. A pointed tool is used finally to further scrape and even the cut edges.

Good carving is uniform in depth and in the edges. Experience

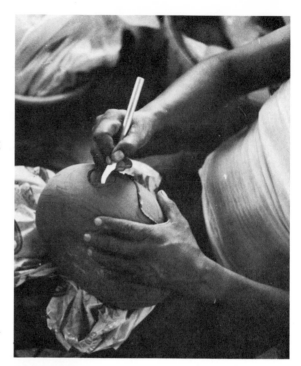

Figure 37. Outlining by cutting
(Kenneth Shupla)

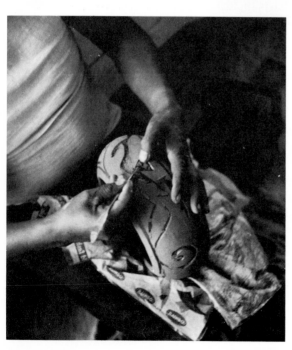

Figure 38. Gouging
between the initial cuts
(Kenneth Shupla)

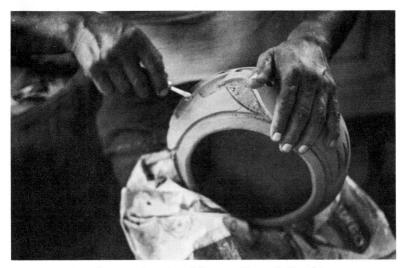
Figure 39. Straightening the sides of the cuts (Kenneth Shupla)

is the best teacher. Many potters said that when they first started
carving they carved through the vessel walls. The thickness of
the walls is judged by lifting and feeling the weight of the vessel
before the potter can estimate the depth for carving. The skill of
the carvers in making accurate cuts of consistent depth is
remarkable.

Next the vessel is set aside to dry. Sanding and smoothing a
carved vessel is a tedious process. Each perpendicular incision
has to be sanded separately as well as the carved areas. After
sanding, the potter smooths the vessel with water, rounding any
sharp cuts and removing any gouging lines left visible. For
narrow cuts, a small rag dampened with water is held on a sharp
tool and forced into the area to smooth and round the edges.

When a carved vessel is first slipped, the carved areas are left
unslipped and unpolished. Slip is applied only to the edge of the
cut and to all the raised areas in the design. Some of the small
points and design elements are difficult to polish.

After the vessel has been polished, the excised areas are
painted with the same clay used for slipping just as the matte
areas on the polished ware are painted. Perpendicular edges on

the cut are painted matte black. It is important to keep any paint solution off the polished surface.

The red carved ware is carved, slipped, and polished as is the black carved ware. The differences in the two wares are in the color of the slip, the paint in the excised areas, and the firing. The slip employed for red carved ware is the same red hematite clay used for Red Polychrome ware. The excised areas are painted with either buff or red paint.

Resist Firing and Incising

In the recently introduced resist-firing technique, pieces of some material (such as, perhaps, aluminum foil) are apparently placed over part of a vessel's surface to keep it from taking on the color imparted by firing. Resist firing is used on both the Polished Black and Polished Red wares; in the case of the black-ware, the shield keeps the carbon from penetrating the vessel during smothering. The result is a buff-colored area on the surface of the vessel. The unfired areas are often decorated by fine incised, or sgraffito, designs.

Firing

The final step in pottery manufacture is firing. The necessary materials and equipment are four to eight tin cans, many sizes and shapes of corrugated tin, metal racks, kindling, kerosene, bark slabs, and, for the Polished Black ware, cow dung and pulverized horse manure. The potters expressed no preference for the kind of bark used; some used cottonwood, while others obtained their bark from local lumber mills.

The pottery is usually fired behind the potter's house, always in the same area, which must be fairly level and free of vegetation. Good weather is essential. If there is a strong wind, firing is usually postponed; moisture in the air is also cause for delay. Most potters fire very early in the morning or in the evening to avoid wind, but if the weather conditions are satisfactory firing is done at any time during the day. It is interesting to note that

even bad weather does not always stop the firing: One potter who had planned to fire and had been delayed by rain for several days built a barricade of large sheets of metal and plywood around her kiln to prevent the wind from hitting the fire and went ahead with firing. She was, however, apprehensive that the wind might shift direction and cause not only smudges but possible breakage from the drop in temperature on one side of the kiln.

Guthe (1925:70) states that a preliminary fire is built, but during the rainy summer of 1968 this was not done.

The potter assembles the scattered cans from the previous firing, the grates, and the corrugated tin. The first step is to stand upright the cans or short lengths of pipe needed to support the kiln. If the kiln is large and several pieces of pottery are to be fired, three cans on a side will be used. Kindling is spread between and around the cans, then saturated with kerosene (Fig. 40).

The potter then constructs the metal box from the corrugated tin. The first piece is flattened and reshaped by grasping the tin at the edge, holding it down with one foot, and bending it to the desired shape (Fig. 41). (Any paint on the tin when it is first acquired is previously burned off; otherwise it would leave spots on the pottery during firing.) The potter places the bent tin on

Figure 40. The kindling and the tins (Belen Tapia)

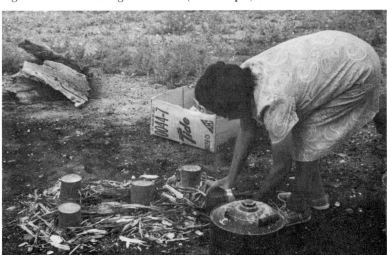

Figure 41. Bending the corrugated tin (Ernest Tapia)

the upright cans. The pottery, which has been stored, is unwrapped and placed on a grill on the bottom of the kiln so that the pieces are not touching; this is most important in firing the blackware (Fig. 42). Another tin is bent to fit over the top, or perhaps several small pieces instead of one large piece. Other small pieces of tin are bent to fit the ends. Some potters put a grill across the top to support the tin and keep the burning fuel from falling on the pottery (Figs. 43 and 44). Bark is propped upright around the edges and is also placed over the entire top of the tin structure (Fig. 45). The construction of the kiln takes about ten minutes.

Guthe observed that at San Ildefonso a grate was placed directly on tin cans or half bricks and the vessels were placed directly on this grate (he did not mention use of corrugated tin):

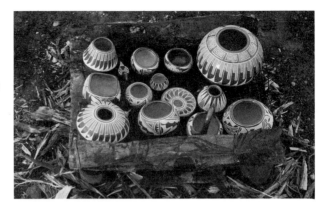

Figure 42. Polychrome pieces in kiln

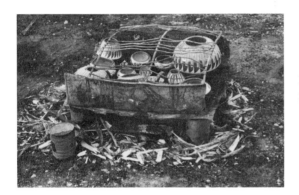

Figure 43. Placing the grill over the vessels

Figure 44. Forming the top of the kiln (Belen Tapia)

Figure 45. Placing the bark around the kiln (Ernest Tapia)

"The vessels are then placed upon the grate in an inverted fashion. No attempt is made to keep them from touching one another. In fact, they are crowded together in order that the greatest possible number may be burned at once" (1925:70, 71).

After the kiln is covered with the bark, the potter holds a rolled piece of burning paper to the kindling and ignites it. Sometimes kerosene is sprinkled on the bark before it is lighted. If the bark falls as it is burning, the potter props it back up with a shovel or rake.

Redware

The fire for red pottery is allowed to burn completely down before removing the pottery—about thirty minutes (Fig. 46). The

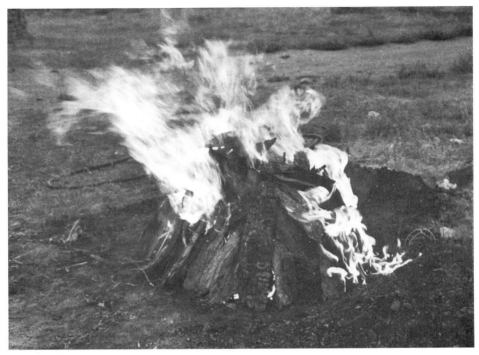

Figure 46. Firing the kiln

heat is so intense that the tin at top and bottom is red hot within twenty minutes after lighting the fire. When the fire has died down, the potter rakes or scrapes away any smoldering pieces, slides the pieces of tin from the top of the kiln, and immediately removes the hot pieces of pottery with a long pole, placing them on a piece of corrugated tin near the fire (Fig. 47). When the vessels are first removed, they are a very dark chocolate brown; as they cool they turn red. The potters say that when the fire is first started the pottery turns black, and as it becomes oxidized it turns dark brown. The potters judge "when it is done" by lifting an edge of the tin and looking inside.

Breakage during firing is not uncommon; even the most experienced potters show some concern when the fire is first ignited. As the heat becomes intense, some vessels explode if they have air pockets or are not completely dried. The potters

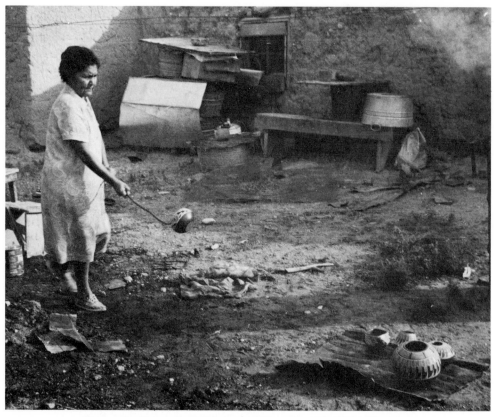

Figure 47. Removing the hot vessels from the kiln (Belen Tapia)

can relax when this danger period is over and consider the firing
a success.

Shepard (1965:87) used a thermoelectric pyrometer at Santa
Clara and recorded a temperature of 750°C. as the maximum
temperature for the Polished Black ware after thirty-nine min-
utes. She did not record any temperatures for the redware.
Because of the expense involved I did not attempt to record fir-
ing temperatures for either style. However, thermal gradient
testing done by Howard Romback shows that the quantity of
alkaline earths present in the body clay acting as fluxes gives a
fired appearance of a sintering effect (see Glossary). This sinter-

ing occurs at the relatively low temperatures of 1500°F. to 1900°F. The body clay shows a very low melting point of 2110°F.

Blackware

The first part of firing the Polished Black ware—to the point of maximum temperature—is the same as for the redware. Cow dung in large dry cakes and pulverized horse manure are placed in containers near the firing area. As the potter constructs the kiln, she adds cow dung and arranges it vertically with the slabs of bark. Fine horse manure is obtained by some potters at stables in and around Santa Fe; a day is reserved when the supply of manure is low for a trip into Santa Fe to replenish it. The manure is shoveled into large gunnysacks and stored in a dry place for future use.

After assembling the kiln, making sure the vessels are not touching, the potter arranges wood and cow dung against the tin (Figs. 48 and 49). When the fire has reached the maximum temperature, it is smothered with fine horse manure (Fig. 50). Shepard (1965:88) says, "As the draft is shut off, the temperature begins to drop. After a few minutes the scraps of sheet metal which protect the pottery from contact with dung, are forked out, and the dung pushed close to the vessels. [At the time of the 1968 fieldwork the potters did nothing to the kiln at this stage, leaving it intact.] The sooty smoke from the smoldering dung settles on the pottery, turning it permanently black since the carbon penetrates the pores."

All the potters are careful to prevent the dung from catching fire. When the heat ignites it, they pat on more dung and smother the flame immediately.

Guthe says, "After the manure has been added, the mound is continually prodded with a poker to redistribute the loose manure and make certain that all the pieces are equally covered" (1925:74). The Santa Clara potters in 1968 left the kiln completely alone unless flames shot from the smoldering pile.

It is at this point that the potter can relax, knowing that if

Figure 48. Polished Black ware in the kiln

Figure 49. The kiln before lighting (Flora Naranjo and daughter, Barbara Martinez)

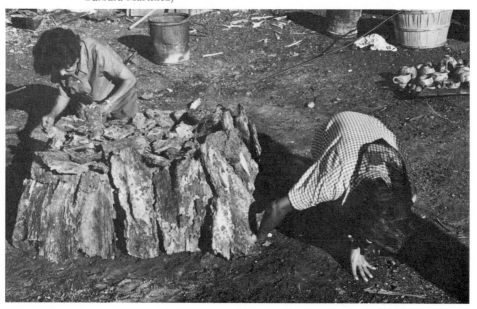

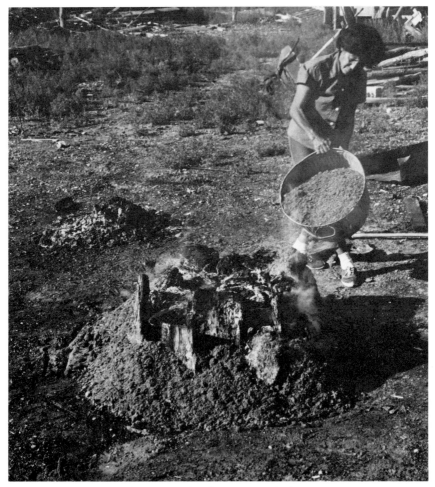

Figure 50. Smothering the fire with fine horse manure (Flora Naranjo)

there is to be any damage it will already have occurred. The length of time the vessels are left in the kiln varies. One potter said it didn't make any difference how long it smoldered and left it for over an hour and a half. Most potters rake the dung away in thirty to forty-five minutes.

At this time the vessels are lifted from the kiln with a long pole and are placed on a piece of metal. As soon as they have

cooled enough to handle, the soot is wiped off with a rag and they are wrapped in newspapers and stored for marketing.

The smoldering embers are extinguished with a garden hose. They are raked back and forth until only smoke remains (Fig. 51).

The potters know that the luster will be reduced if the temperature is too high. The Santa Clara potters strive for a highly lustrous blackware and recognize a gunmetal gray color as being caused by too high a temperature before smothering: "They smother the fire before shrinkage commences and, if a vessel comes from the fire with dull or semilustrous spots where flame has played on it, they explain that it got too hot" (Shepard 1965:88).

Figure 52 is a photograph taken by Curtis in 1905, showing potters smothering their fire. The caption is: "Only with considerable practice can pottery be fired successfully. The vessels and the surrounding fuel of dry dung must be so placed, and the fire must be so controlled that, while perfect combustion takes place, high temperature shall not develop too quickly. Cracked and blackened ware is the penalty of inexperience and carelessness" (Curtis 1926:Photograph 603).

Marketing

Growing awareness of and interest in Indian arts have brought about greater profits for the potters and have expanded the market for pottery and other Indian arts.

During the summer months—from May until October—the potter retails her own pottery to the tourists. The retail market has grown beyond the tourists who stop at the pueblo and the Indian who sells her wares in front of the Palace of the Governors in Santa Fe. It includes the Indian market held in Santa Fe in August each year, the Gallup ceremonials, all the Pueblo feast days, the Flagstaff Powwow, the Santa Clara ceremonial at Puye, and other ceremonials held in the South-

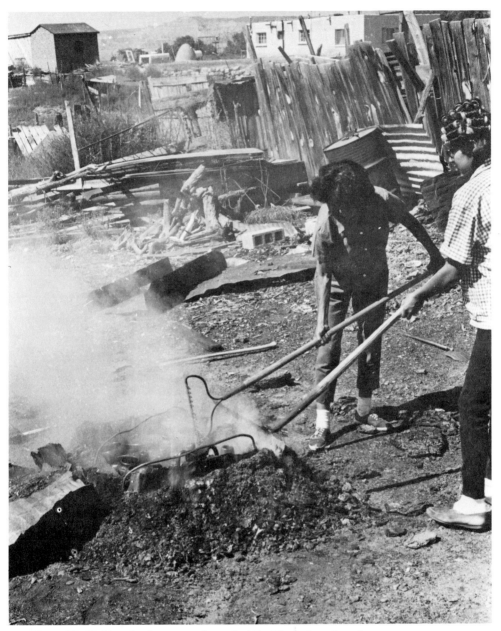

Figure 51. Raking the dung away from the kiln (Flora Naranjo and
Barbara Martinez)

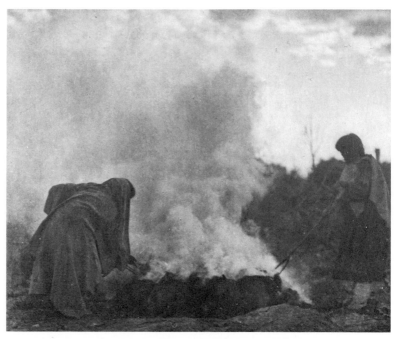

Figure 52. Firing the pottery (Curtis 1926:Photograph 603)

west. One of the better known potters from Santa Clara has shipped her pottery as far away as Japan.

The potter prices her own ware but is pressured by the other potters to keep her prices comparable to theirs. A potter is criticized and ostracized for underselling another. Potters establish their prices according to the size of the vessel and the demands of the consumer. The potters are aware of the increased prices in the curio stores and know that consumers are paying these higher prices. The artist in turn increases her own retail and wholesale price. The wholesale price is one-half to one-third of her established value. Wholesaling is usually confined to the fall and winter months—October through April—although occasionally at the end of a market a potter who has some of her wares left will wholesale them to a dealer.

According to my informants, there are two ways a dealer can stock his store with Indian arts. One is to buy directly from the Indian at the pueblo; the other is to buy from a trader who purchases from the Indian. Many retail dealers prefer to deal with a trader, for several reasons. The dealer can choose the pieces he wants for the clientele he serves; the trader will generally buy every piece a potter has to sell. The trader is usually located near the potter and has established a rapport and trust. He knows the going prices and is in a good position to recommend prices to the retailer. If the retailer makes the long trip to purchase his pottery, the selection and variety will probably not be as great, breakage may be a problem, and potters may not have any pottery for sale. The traveling expense would in turn have to be passed on to the purchaser. Ten years ago it was not uncommon for a potter to be indebted to a trader who had advanced money to her against her future pottery production; she would then have to sell the pottery to him at a low price. This situation has changed with the increased competition for pottery, and the trader's role is now helpful to both the Indian and the retail dealer.

Since 1965, the price of Indian pottery has almost tripled. The cost of a piece of Santa Clara pottery depends on the quality of the piece and the reputation of the artist. A 4-inch bowl from a potter who is not yet signing her pieces and who has not perfected polishing and decorating techniques may sell for as little as $10. A 12-inch carved piece signed by a well-known artist will cost around $800. Joseph Lonewolf sold an intricately etched bowl in 1974 for $4,800.

In summary, the marketing and distribution of Indian pottery are relatively simple. Sophisticated techniques such as marketing research, advertising, and organized sales programs are not used. Dealers and traders seek quality work from the artists and bring it to the public for sale. The role of the Indian continues to be one of design and manufacture, although it is becoming more common for an established artist to have a private or public show to display and sell her latest creations.

Conclusion

In 1968 the Santa Clara Indians were still gathering all the raw materials used in making pottery, but the processing of these materials had changed somewhat from the time of Guthe's fieldwork at San Ildefonso in 1921. The loose clay was brought home directly from the pits, laid out to dry, and then put in large buckets to soak in water. No ceremony was observed in gathering the clay. The tempering agent and the soaked clay were prepared separately and then mixed together on a piece of canvas.

Modeling, by the coil method, had not changed. The tools used in all the processes had changed and had been adapted from modern utensils. Polishing stones were often purchased from lapidary shops.

The firing process reflected another change. Corrugated tin, which was not used when Guthe observed firing, was used at Santa Clara in 1968 to construct the kiln. Kerosene was used to start the fire, but tree bark and cow and horse manure were still being used for fuel, as in the earlier period.

New decorative techniques had been introduced since 1921 at Santa Clara. These included matte painting on the Polished Black ware, carving on both redware and blackware, polychrome painting on the Polished Red ware, and a recent resist-firing technique.

From the data collected it appears that the Santa Clara potters are adapting new resources for the sake of convenience but are still producing pottery that is little changed in construction or firing from the ways passed down to them by their ancestors.

APPENDIX A
The Evolution of Santa Clara Pottery

The Early Period: 1879 to the 1920s

The earliest known documented pottery from the Rio Grande pueblos was collected by Stevenson and Cushing in 1879. At the same time, E. W. Nelson was sent by Powell into the pueblo area to collect artifacts. I examined both of these collections at the Smithsonian Institution in 1969.

In 1879 three major pottery types were made at Santa Clara: Polished Black, Polished Red, and a micaceous ware (Fig. 53). While Stevenson (1883:430) described a White Painted ware in his notes from the field trip in 1880, no such specimens were in his collection at the Smithsonian Institution.

Jeançon, who did a field study at Santa Clara in 1906, said, "A few potters made a ware with a white or cream colored slip and polychrome decoration but had discontinued it prior to the turn of the century."

Polished Black Pottery

The following description for surface finish applies to all the Polished Black vessels examined. The exterior surface of bowls, jars, and large vessels is slipped and polished on the upper two-thirds of the body with striations from the polishing stone creating small troughs parallel to the rim. The color is glossy black with little variation. Small mica sparkles and micro

Figure 53. Vessel shapes, 1879–1970

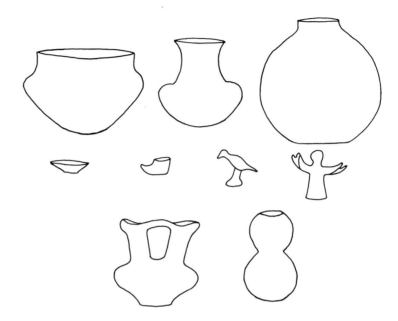

POLISHED BLACKWARE 1879–1920

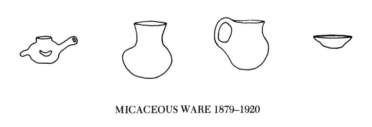

MICACEOUS WARE 1879–1920

PAINTED WARE 1879–1920

POLISHED BLACKWARE 1880–1920

POLISHED BLACKWARE 1920–1970

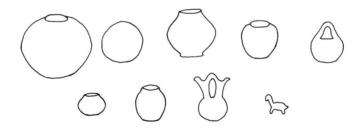

POLISHED REDWARE 1920–1970

WHITE POLYCHROME PIPES 1920–1940

spalling, which occur when mica is present in clay, were evident with a four-power hand lens, as was crazing, which affects the gloss measurement (see Glossary).

The lower third, or basal area, is semiglossy and light gray to black in color. This kind of surface, unslipped but polished, is commonly referred to as a floated surface. It has been scraped with a tool while the vessel was in the leather-hard stage, and the shallow troughs remain (see Shepard 1965:Figure 13). The troughs are generally parallel to the base of the vessel and are 1/8 inch to 5/16 inch wide. Fireclouds are not uncommon on this area. Polishing stone troughs are evident, but are not as deep as on the upper slipped surface.

Interiors of restricted-rimmed vessels are neither slipped nor polished except for the area from the rim down to about 1 inch, which is both slipped and polished. The interiors of restricted-rimmed vessels are rough to the touch and dark gray in color. Unrestricted-rimmed vessels are generally both slipped and polished on the interior, but the exterior surface is floated. The wall thickness of these vessels ranges from 1/4 inch to 3/8 inch.

Painted decorations never occur on Polished Black pottery before 1927. Some vessels are decorated with shallow impressions on the neck or shoulder. Handles are occasionally attached to the shoulder on large storage vessels, but these were not popular until after 1880. Fluting or scalloping of the rim is a decorative technique that was popular on water jars or shallow dishes.

The earliest documented "bear paw" impression from Santa Clara to be found in museums was collected in 1903 by Pepper from the Museum of Natural History in New York. Bear paw impressions were also found at Casas Grandes in the Tardio Period, c. A.D. 1340–1660 (Amerind Foundation 1969:13). Stevenson made no reference to the bear paw motif at Santa Clara when he was examining and collecting pottery. Thus it seems reasonable to assume that none was present in either 1879 or 1880.

Vessels collected by Stevenson in 1879 were jars for water

storage, large food storage vessels, canteens, cooking vessels, "eating bowls," and wedding jars. These utilitarian shapes continued well into the twentieth century. Unusual forms collected were bird effigies with and without pedestals and boots.

Food storage jars. The most common shape in this classification is a globular body with a restricted neck and a slightly recurved rim. The vessels range from 6 inches high to very large jars 24 inches high, with diameters from 9 inches to 22 inches. Bases are either flat or concave. The size of the vessel does not seem to be the determining factor in the basal shape; the largest jar examined in this class has a concave base, while the second largest has a flat one. Decoration is rare, but straight or wavy depressions do occur around the body.

Large bowls. Vessels classified under this heading are "dough bowls" and large storage bowls. There is more variation of the body form, which may be ellipsoid, ovaloid, or spheroid, than in any other vessel. Bases may be slightly concave or flat. Necks are restricted with recurved, slightly flaring rims. The interior surface is unslipped. Some vessels are polished, others only smoothed; the interior is smooth to the touch. Color on the upper exterior surfaces is glossy black with a semiglossy gray to black on the basal and interior surfaces. Sizes range from 5 to 12 inches in height and 11 to 17 inches in diameter. There is no correlation between the size of the vessel and wall thickness, which varies from 1/4 inch to 5/16 inch. The only decorative treatment occurs at the junction of the neck and the shoulder as an encircling indentation.

Small bowls. This classification includes unrestricted-rimmed vessels from 5 to 10 inches in diameter and 4 inches or less in height. The exterior is unslipped but polished, with a color range from dull gray to black. The interior of the vessel has been slipped and polished glossy black and scored from the polishing stone. The orifice is always unrestricted with a wide variety of shapes, which include spheroid, ellipsoid, ovaloid, and rectangular. Bases are either flat or footed. Rims are vertical or gently

recurved outward. The wall thickness averages 3/16 inch. The decorative treatment is limited to scalloping or notching of the rim. Occasionally interiors of the bowls are ornamented with spirally arranged depressions.

Water jars. This vessel is more typical of Santa Clara pottery than any other in this period. The body is ovaloid, the rim recurved, and the neck long and sloping toward the shoulder. The typical treatment of the rims is fluting or scalloping. The junction of the neck and the shoulder is always treated with an encircling indentation. Two parallel indentations that form a square ridge in between are not uncommon. Bases are generally concave, but some flat bases do occur. All of the vessels of this class (I examined twenty-five) were sorted by size and shape; the smallest is 7¼ inches, the largest 12¼ inches in height. There is much less variation in the diameter of the bases. The narrowest diameter is 3 inches, the widest 4½ inches. The wall thickness varies from 3/16 inch to 5/16 inch, the most common being 1/4 inch. Decoration on the water jar is limited to indentations on the neck of the vessel or fluting of the rim. Also, the indentations that emphasize the shoulder would be considered a stylized technique for decorating this vessel.

"Two-storied" water jars. The vessel shape was recognized by one informant as being a water container used at mealtimes. There are no decorations. The two-storied effect is made by an indentation or constriction in the center of the body. The upper portion of the vessel is spheroid, the lower ovaloid. The base is generally concave. The rim is recurved and slightly flaring.

Bird effigies. The effigy is modeled with a head, a beak, indentations to suggest wings, a full body, and a short tail. The bird generally stands on a round pedestal 1 inch high with a round or cloverleaf-shaped base. The overall height averages 4 inches. The entire form is slipped and polished; the color is a glossy dark brown to black. Stevenson collected some hollow forms with an orifice in the back that were not on pedestals. He also refers to a canteen in the shape of a bird with no pedestal. I did not see these last two forms.

Boots. This item is a small replica of the Pueblo moccasin. The

average height is 3 inches, the length 5 inches. The entire exterior surface is slipped and polished except for the base or "sole," which is unslipped and unpolished. "Toes" are either turned up and pointed or rounded at the tip. The soles may be emphasized with a modeled sole ridge.

Wedding jars. The body of the vessel is spheroid or ovaloid; it always has a double spout with a stirrup handle joining the two spouts. Decorative treatment includes vertical impressions on the body, and after 1903 the bear paw impression was a common decorative treatment always indented on the body of the vessel. The jars range from 11 inches to 16 inches in height. The diameter of the body ranges from 7 inches to 11 inches. The bases are either concave or flat; most are flat.

The wedding vase is reported to have been used in Indian wedding ceremonies. One informant said that she was the last one to use the vase in her wedding, about 35 years ago. However, there are no data to indicate this for the past. Bruce Ellis (personal communication) suggests that the trader at the Original Curio Shop in Santa Fe who bought pottery in the early 1900s originated the shape and story and gave them to the Santa Claras. No other Tewas, or Pueblos for that matter, have such a custom.

This story of the wedding vase was told to me by Teresita Naranjo of Santa Clara Pueblo:

After a period of courtship, a boy and girl decide to get married, but they cannot do so until certain customs have been observed. The boy must first call all his relatives together to tell them that he desires to be married to a certain girl. If the relatives agree, two or three of the oldest men are chosen to call on the parents of the girl. Here they pray according to Indian custom and then the oldest man will tell the parents of the girl what their mission is. The parents never give a definite answer at this time—they just say they will let the boy's family know their decision.

About a week later, the girl calls a meeting of her relatives. The family then decides what answer should be

given. If the answer is "no," that is the end of it; but if the answer is "yes," the oldest men in her family are delegated to go to the boy's home to give their answer and to tell the boy on what day he can come to receive his bride-to-be.

Now the boy must find a godmother and a godfather. The godmother immediately starts making the wedding vase so that it will be finished by the time the girl is to be received. The godmother also takes some of the stones which are designated as "holy" and dips them into water to make the "holy water" with which the vase is filled for the day of the reception. The boy also must notify all of his relatives on what day the girl will receive him so that they will be able to buy gifts for the girl.

The reception day finally comes and the godmother and the godfather lead the procession of the boy's relatives to the home of the girl. The groom-to-be is the last in line and must stand at the door of the girl's home until the gifts have been received and opened by the girl.

The bride and groom now kneel in the middle of the room with the boy's relatives and the girl's relatives praying all around them. After the prayers, the godmother places the wedding vase in front of the bride and groom.

The bride then drinks out of one side of the wedding vase and the groom drinks from the other. Then the vase is passed to all in the room—the men drinking from one side and the women from the other.

After the ritual of drinking the "holy water" and the prayers, the girl's family feeds all the boy's relatives and a date is set for the church wedding. The wedding vase is now put aside until after the church wedding.

After the church wedding, the wedding vase is again filled with any drink the family may choose and all the family drinks in the traditional manner—women on one side, men on the other.

The wedding vase has served its ceremonial function and is now given to the young couple as a good luck piece.

Stevenson states:

> It is proper to add here that the clays used by Santa Clara Indians are of a brick-red color, containing an admixture of very fine sand, which, no doubt, prevents cracking in burning, and hence dispenses with the necessity of using lava or pottery fragments, as is the custom of the Indians of the western pueblos. The burning is carried on until a sufficient degree of heat is obtained properly to bake the vessels, which still retain their original red brick color. At this junction such of the vessels as it is desired have remain in that condition are removed from the fire and allowed to cool, when they are ready for use. Those which the artists intend to color black are allowed to remain and another application of fuel, pulverized, is made, completely covering and smothering the fire. This produces a dense, dark smoke, a portion of which is absorbed by the baking vessels and gives them the desired black color. It is in this manner that the blackware of these eastern pueblos is produced (1883:331).

From this statement it is assumed that the potters of Santa Clara made Polished Red pottery, but no documented specimens prior to 1880 were found in the museum collections.

One of the greatest impacts on Santa Clara pottery came in 1880 with the advent of the railroad that ran through Española into Santa Fe, opening the area to increased tourism. Vessel shapes became highly diversified at this time because of the expansion of this market. Small items were introduced in only two wares, the blackware and the redware.

The smaller vessel shapes include pitchers modeled after cream pitchers, vases of different sizes and shapes, restricted-rimmed bowls with and without lids, round and oblong shallow dishes, and cups. One unusual modeled shape was a railroad train with a Polished Black engine and coal car and a Polished

Red car. The larger vessels were restricted-rimmed bowls for tourist sale after 1880. Candlestick sconces (Museum of New Mexico Catalogue Card Number 45552/12) are also common.

Decorative treatment after 1880 includes pointed studs of clay added to the shoulder or body of vessels and diagonal or vertical impressions on the necks, shoulders, or bodies. Almost all of the tourist items have handles of varying shapes and forms, but the most characteristic is perpendicular to the neck and shoulder. This period could almost be referred to as the "Period of Handles," in fact; they are so typical of the time.

Micaceous Ware

According to Jeançon, micaceous pottery, a cooking ware, had not been produced for twenty years prior to his fieldwork in 1906. He describes the ware as follows:

> This was a cooking ware of very coarse paste which was heavily filled with powdered mica. It had a brownish-red undertone, and the mica wash with which it was finished gave it a glisteny surface that was pleasing to the eye. Cook pots, food bowls and jars were the commonest form of this ware, which resembled a prehistoric ware found all through the southwest but which is more common in the ruins of the Jemez Plateau and the adjacent country. Most of it is friable, easily broken and easily disintegrated with continual use. It was rather carelessly made. For kitchen purposes it was almost the only ware used up to twenty years ago (field notes).

Hill includes a description in his manuscript:

> A third micaceous type was derived from the Chimayo Valley. Some villagers journeyed to the sites; others obtained it from the neighboring Spanish-Americans who came to the pueblo to trade. According to one informant it formerly occurred near Santa Clara but the beds were

covered through flood action and Santa Clara obtained it from the Picuris. It was used in making cooking wares.

A few women were still making an occasional pot in the 1940's (informant). The construction of this type of pottery followed the general pattern of that described for black and red wares. The micaceous clay, however, did not require the addition of temper. According to informants this clay was "stronger" and kept its form better during the coiling process. For the same reason pots of this material were constructed of a coarser paste and the walls were thinner. They dried more rapidly than other wares. . . .

When dried the pots were smoothed both inside and out with a wet corn cob. They were fired for about an hour. This produced a yellow ware; if overfired, reddish. Normally the culinary wares were pinkish yellow before they became smudged from use in the open fire. Some potters rubbed piñon pitch on these pots immediately after firing. This was said to strengthen them.

There was little variation in the micaceous cooking vessels except in size. They were globular in shape with modified rims. They averaged between ten to fourteen inches in height and eight to ten in diameter. The size of the opening was variable. Occasionally, these so called "bean pots" were equipped with handles (1940).

This type of utilitarian ware was collected by Stevenson in 1879. The general appearance is the same as that of modern Picuris pottery. The color ranges from buff to orange; variation often occurs on the same vessel due to firing conditions. Fireclouds also occur. The exterior and interior surfaces are unslipped and unpolished with a generally rough texture. The surface has a micaceous wash, which makes it glisten.

Only five shapes of the micaceous ware are documented as Santa Clara pottery in museum collections: a water jar, a bird effigy jar, a water canteen, a bean pot, and a shallow unrestricted-rimmed bowl.

Water jar. Except for the difference in clay and color, the

water jar is like the Polished Black ware. The wall thickness is 1/4 inch, the body is spheroid, and the base is concave. The vessel is 7¾ inches in diameter, with an orifice 5¾ inches in diameter. The only decorative treatment is a scalloped rim with vertical indentations on the neck and an encircling indentation at the shoulder.

Bird effigy jar. The body is spheroid, the base is flat, and the rim is restricted. Decorative treatment includes two handles on the body on opposite sides, with a modeled neck and head at one side of the body and a short tail opposite the head, which give the vessel a birdlike appearance.

Water canteen. The height of the water canteen is 5½ inches; the length from the spout to the tail, 8 inches; the width of the body, 6½ inches. The modeled tail makes it resemble a bird. The decorations consist of two handles on opposite sides of the body modeled of the same clay as the vessel, a handle on the top, and a tail attached opposite the spout. There are also vertical indentations on the upper half of the exterior.

Bean pot. This vessel is spheroid in shape, with a restricted, flaring rim. The rim has the typical fluting treatment of the Polished Black pottery. The base is flat. One handle extends from the rim to the shoulder of the vessel.

Shallow bowls. The shallow bowls are shaped like the Polished Black ware bowls of the same type. They are 2 inches high, 5½ inches long, and 4½ inches wide. The wall thickness is 1/4 inch.

Polychrome

Stepped-edged polychrome ceremonial bowls were known to have been used on the altars of some of the kiva groups from Santa Clara, according to Hill (1940). But both he and Jeançon (1906) agree that very little of this ware was made by the Santa Clara potters. Most of this type was traded from San Ildefonso. According to Jeançon, the potters from Santa Clara who did

manufacture a ware with white or cream-colored slip and poly-chrome decorations discontinued it prior to the turn of the century. Although Stevenson (1883:446) illustrates a turnip-shaped polychrome canteen of this type, I was unable to find it at the Smithsonian Institution.

The Modern Period: The 1920s to the 1960s

During the 1920s, interested people such as K. M. Chapman, S. J. Guernsey, F. W. Hodge, A. V. Kidder, H. P. Mera, and others in the Santa Fe area realized that Indian arts were deteriorating. In 1922, the Indian Arts Fund, first known as the Pueblo Pottery Fund, was started with a twofold purpose: first, to preserve all the handicrafts of the various Indian tribes of the region, in essence to keep a pottery record; second, to return to the Indians the best of their art and to help them improve their pottery as well as their other arts. This aim, it was felt by the members, would encourage better standards of workmanship in the Indians' modern arts (Johnson 1925).

It was also during the 1920s, according to one of my informants, that a trader from Española came into the village in a wagon and traded metal cooking utensils and food for pottery. This reduced the need for pottery food receptacles and increased the amount of pottery available for sale.

During this period four types of pottery were being manufac-tured at Santa Clara: Polished Black ware, Polished Red ware, a White Polychrome ware, and a Buff Polychrome ware (Fig. 53). Variations in the Polished Black ware include matte black painting on the polished black surface (the first painting was in 1927), carving, and buff design areas on a polished black surface. Variations in the Polished Red ware include polychrome paint-ing and carving, with the carved areas painted either buff or light red.

Polished Black Ware

Polished Black ware includes painted blackware, carved blackware, and plain polished blackware. Slip is applied to the entire vessel on the exterior surface. This surface is completely and evenly polished; any facets left by the polishing stone are very shallow. The surface color is jet black with a high degree of luster. Very small particles of mica can be seen with a four-power hand lens, creating almost unnoticeable spalling. Mica spalling has been corrected recently by sifting the clay through a very fine mesh screen, eliminating any large particles of mica. Crazing is very minimal.

It would appear that contemporary potters achieve a high degree of luster by applying only enough slip to the vessel to give it a uniform color and by firing at a very low temperature (see "Firing," pp. 56–66).

The interiors of all restricted-rimmed vessels are left unslipped and unpolished and are rough to the touch. The rims are generally slipped and polished 1/2 inch to 1 inch down into the interiors. Bases are left unpolished and unslipped. Unrestricted-rimmed vessels are slipped and polished on both the interior and the exterior surfaces. Wall thicknesses have increased over the earlier period, from 5/16 to 3/8 inch, with the most common being 3/8 inch even on very small pieces.

In 1922 or 1923, Sarafina Tafoya introduced a new design technique that may have provided the stimulus for carving (4297/12 Indian Arts Fund Collection, School of American Research). This catalogue card reads, "One of about 12 made about 1922-3 by Sarafina Tafoya. Statement from Teresita Naranjo 2/15/55 to F. H. Douglas and agreed by Severa Tafoya." Similar vessels I examined are globular, restricted-rimmed bowls with flaring rims 8 inches to 9 inches high and 11 to 12 inches in diameter. They have indented designs of zoomorphic figures at the shoulder and the entire vessel surface is floated; the color is light to dark gray. The design area is slipped, polished, and jet black in color. The interior of the rim is also slipped and polished.

Decorating by painting matte black on Polished Black ware makes its first appearance at Santa Clara in 1927. A piece donated to the Lowie Museum of Anthropology, University of California, Berkeley, by E. W. Gifford was accompanied by a letter of documentation containing the following information:

> The black pottery came from Santa Clara and each piece was specially made for us as we had gained the confidence and friendship of one of the ex-governors of the tribe, Santiago Naranjo; and also his daughter Olojia who was medicine woman of the tribe at the time we were there, 1927. They had been making black pottery only a very short time then. One piece, about eight inches in diameter and three deep with a crude pattern is the FIRST piece of black work attempted at Santa Clara. "FIRST piece of black work" refers to the first matte painting on the polished blackware (Catalogue Card Number 2-15939).

One other Polished Black ware made in the early 1930s for only a few years was an orange-on-black ware. The orange geometric designs were painted on with a Duco paint after the vessel had been fired. The designs painted on these pieces wiped off. Documentation with a piece in the Denver Art Museum says, "An example of a ware that was popular for awhile in the early 1930's and then vanished. The shops in Santa Fe were full of it in 1932. It preceded violent showcard polychromes now popular (1951)" (Catalogue Card Number XSC-82-G).

Indentations, such as the bear paw and impressions on the body to suggest a melon bowl, gained in popularity during this period. Carving on the Polished Black ware gained impetus in the 1940s. Plain or twisted handles were sometimes attached on opposite sides of vessels, but they were not as common as in the earlier period and seemed to be decorative rather than functional.

In the late 1960s, a new style that appears to use a resist-firing technique was executed by Camilio Tafoya, Grace Medicine Flower, and Joseph Lonewolf of Santa Clara and Popovi Da of San Ildefonso. Buff areas remain on the Polished Black or Polished Red surface and within these areas designs are

scratched into the slip after it is polished. This sgraffito technique is a carefully guarded secret.

The most common shapes in this period were vases, open and restricted-rimmed bowls, shallow ashtray dishes, wedding jars, and animalitos. All of the pottery vessels manufactured during this period were for sale; no vessels were manufactured for utilitarian purposes. Most of the vessels were small, not over 8 inches high. The exceptions were vessels 24 inches high produced by Margaret Tafoya.

Vases. Vases are ovaloid with restricted rims. Generally, contemporary Santa Clara pottery has a straight rim on both restricted and unrestricted vessels. Bases are always flat. The exterior surfaces have the characteristics of Polished Black ware described previously. The interiors are unslipped and unpolished. Sizes range from small—3 inches in height—to the few large 24-inch pieces. Wall thicknesses have increased from 5/16 inch to 3/8 inch. The decorative treatment on these vessels includes painting in matte black, bear paw indentations, and carving, generally executed on the upper two-thirds of the vessel. Some potters carve the Avanyu (feathered serpent) on the body of the vessel. Curved handles attached to the rim and body are decorative rather than utilitarian.

Bowls. Bowls are either spheroid or ellipsoid with unrestricted or restricted orifices. A unique variation common at Santa Clara is the restricted-rimmed vessel with the upper surface flattened at the shoulder, making the vessel square or hexagonal at the rim. The flattened areas are decorated. The sizes range from 2½ inches to 10 inches in height. The wall thicknesses range from 5/16 inch to 3/8 inch. The increase in wall thickness in this period is probably so that patterns can be carved in the walls without piercing them. The exterior surfaces are slipped and polished on the restricted-rimmed vessels and the interior surfaces are unslipped and unpolished. The unrestricted-rimmed vessels are slipped and polished on both the interior and the exterior. Unrestricted-rimmed vessels are decorated on the interior, while restricted-rimmed vessels are decorated on the exterior. Decorative treatment includes carving, painting in

matte black, and impressing indentations on the body to create the melon-bowl effect. Ordinarily the bear paw is not used on this shape. Handles are not commonly used on restricted-rimmed bowls, but unrestricted-rimmed ones may have a single handle over the top giving a basketlike effect or two twisted handles at the rim.

Shallow ashtrays. The height of ashtrays is not more than 1½ inches. The rims are unrestricted. The shapes vary from oblong to round; the thunderbird effigy is not uncommon, with the triangular tail attached to an oblong body and a head opposite the tail. These dishes are usually painted with matte black rather than being carved.

Wedding vases. The wedding vase is a double-spouted, stirruped vessel with a spheroid body. The size ranges from 4 inches to 14 inches in height. Bases are flat on contemporary vessels. Wedding vases are usually carved but may be painted with matte black or impressed with a bear paw. The decorative treatment is always on the body.

Animalitos. Douglas says that animalitos were first modeled in 1910 by little girls (Catalogue Card Number ASC-116-G, Denver Art Museum). He believed the inspiration came from comic-strip characters. Children often sit and model animals while their mothers are making pottery. Beavers, ducks, pigs, turtles, bears, seals, and other figures are sold by the Santa Clara potters. These animals are ordinarily small, ranging from 1/2 inch to 7 inches in length. They are highly polished and some are painted on the back. They are very realistically modeled. The eyes are usually indented holes.

Polished Red Ware

The following description for surface finish applies to all the Polished Red wares examined. The entire vessel is slipped and polished with a red slip. The surface is slightly streaked from an uneven distribution of the slip. Polishing stone facets are very shallow. Mica sparkles on the slipped surface are in evidence

when held to the light. Minute crazing is also evident with a four-power hand lens. The slipped surface is very glossy.

The exterior on restricted-rimmed vessels is slipped and polished, while the interior is smoothed but unslipped and unpolished. The interior of the rim is slipped and polished down to ½ inch.

Decoration on redware includes both carving and painting. Decorating redware began at Santa Clara in 1930 with the introduction of white paint. Since that time painted redware has increased in popularity. After 1940 three earth colors were added—weak red (10R 5/4 or 10R 6/6), buff (10YR 6/4, 10YR 6/3, or 10YR 7/3), and gray (7.5YR N4/, 2.5Y N6/, or 2.5YR N5/), on the Munsell Soil Color Chart. The colored designs are always outlined with a white clay.

Two varieties of red carved ware are differentiated by the color of paint used in the carved areas. One is painted with weak red, the other with buff (10YR 6/4 or 10YR 6/3).

Realistic pictures painted on the Polished Red ware first appeared in 1940. Douglas discovered that the trend started when children in art classes painted animals with water paints (Catalogue Card Number XSC-62-P, Denver Art Museum). Some of the potters then began to use these animals on their pottery. The scenes were first executed with polychrome paint, but recently realistic scenes have been carved.

Shapes for the redware are like those for the Polished Black ware. The only difference is in the paint colors and firing technique.

White Polychrome Pipes

A few pottery pipes decorated with a creamy white slip and painted with pale blue and pink designs were made in this period. The slip has the appearance of a crackle glaze. This surface is semiglossy, with polishing stone facets in evidence. The designs were crudely executed with a pale red or pale blue

watercolor applied after slipping but before polishing. The entire pipe was then polished.

Buff Polychrome Ware

In 1930 Lela and Van Gutierrez began to use local colored earths, not previously used by the Santa Claras, for paints. By trial and error, Van found which ones would work and how to control the colors. This style first started as a red slipped and polished vessel with the design at the shoulder on a matte buff background. The paints were gray, brown, rose, and pink outlined with black. The designs in 1930 were similar to those of other artists of the village. Since 1956 Lela and Van (1930–60) and their children, Margaret and Luther, have developed a unique style. Very fine line designs are executed with black outlining on a semiglossy buff background. The motifs are usually anthropomorphic. Areas within the outline are painted with weak red (10R 5/4), brick red (10R 4/6), green, blue, and white. Most of their vessels are similar in shape to the other Santa Clara pottery. The Gutierrez family also models large stylized owls and animalitos.

APPENDIX B
Design Analysis

Shepard (1965:266) defines *elements* of design as those components that are basic and irreducible (see Fig. 54). Simple designs are often made up of arrangements of one or more of these elements; however, in a more complex design, the significant parts are groups of these elements, called *motifs*. The motifs may or may not have symbolic meanings (Fig. 55).

Figure 54. Design elements in Santa Clara pottery

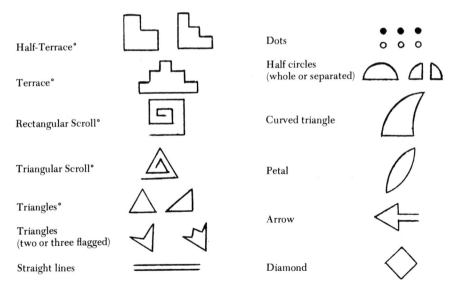

Half-Terrace°

Terrace°

Rectangular Scroll°

Triangular Scroll°

Triangles°

Triangles
(two or three flagged)

Straight lines

Dots

Half circles
(whole or separated)

Curved triangle

Petal

Arrow

Diamond

°Raynolds 1941:122

Lambert (1966:19) found that symbolism on pottery is almost always confined to religious and ceremonial vessels among the Pueblo Indians. Information regarding the meaning of symbols used in decoration is difficult to obtain or is contradictory. In the more conservative pueblos potters will often say they do not know the meaning of the designs used, though they readily recognize a ceremonial vessel by the symbols painted on it. Symbolism is and has always been important in the Pueblo way of life. The symbolism of pottery made for ceremonial use is usually understood by the elders of the village, but the designs used on the commercial wares are without meaning or their original significance has been forgotten.

Weather phenomena (rain, hail, lightning, wind, and so on) are seen as anthropomorphic spirits by the Pueblos, according to Parsons (1939:x). She feels that the terraced figure, so common to Tewa art, represents clouds (Fig. 55a). Spinden (1911) explained the rainbow as follows: The upper diamonds above the rainbow are scattering clouds; below the cloud cover and above the rainbow is a fringe of light; under the rainbow is the open sky; a mass of white cumulus clouds appears above the horizon line, which runs out at either end into the distance; below the horizon line is level ground, and under it are roots, which benefited by the downpour; and from the center of the ground line springs a flower, a sequel to the rain (Fig. 55b).

Bears and mountain lions are thought of as supernatural beings (Parsons 1939:273) and are often portrayed on ceremonial bowls (Spinden 1911:192). Laski (1958:87) feels that bird feathers and snakes are also important ceremonial symbols. Koshare (clowns), the Avanyu (feathered serpent), and other major deities commonly appear on sacred vessels. Figure 55c depicts a cloud symbol and a Koshare, which were copied from a ceremonial bowl at the Laboratory of Anthropology (Catalogue Card Number 5912/11) with the following notation: "Jim Riley said that he had gotten it from Santa Clara Indians who had gotten it from Puye."

According to Laski (1958:87), the sacred cornflower is the invisible symbol of blessing. Its visible reminder is the flower-

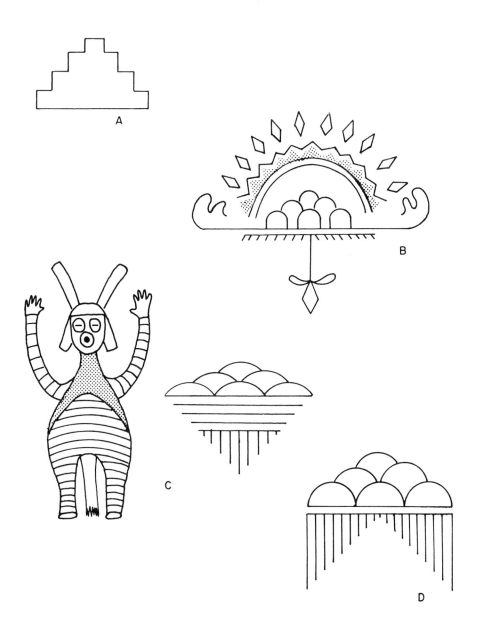

Figure 55. Symbolic motifs in Santa Clara pottery

shaped rain cloud that promises rain to the thirsty Mother earth. It is graphically represented in a design of pyramidlike clouds from which raindrops are falling (Fig. 55d).

Parsons (1939:273) says that the Avanyu, a major deity of the Pueblos, sends water and is an arbitrator of morals. Hewett (1945:29) feels: "The symbol . . . has been consistently interpreted by the Pueblo Indians as a conventionalized design derived from the plumes of the Avanyu, or plumed serpent, the major deity of the Pueblos, and agrees in many respects to the Quetzalcoatl of the Aztecs, and Kukulcan of the Maya, and the plumed serpent of Indian cosmology throughout the areas of sedentary aboriginal life on the continent."

Each serpent on contemporary Santa Clara pottery is breathing "lightning" from its mouth and has a head with a curved horn at the top and an eye in the center. The curves on the body, which encircles the entire vessel, are emphasized with either triangles or pendants at the top or at the bottom of the curve. A pointed tail at the end of the motif completes the serpent (Fig. 56).

In 1968, only one informant made any comment regarding the meaning of symbols found on pottery for tourist sales. He said that the terraced figure stood for kiva steps, the rectangular scroll signified a path to the kiva, and the feather design element related to bird feathers. Most of the artists said the designs were drawn to fit the shape of the vessel and "to look good." Guthe (1925:85) in 1921 felt that the designs on pottery turned out by the San Ildefonso potters for sale to tourists had no special meaning. I am inclined to agree with this point of view.

The contour and angles on a vessel naturally influence the area of design. These angles form natural limits for the areas of decoration. The vase with a sloping neck lends itself to a design from rim to shoulder. Flat plates from Santa Clara are generally decorated with natural scenes that fill the upper surface except for the banding line at the edge. Bowls are generally decorated from the rim to within the lowest third of the base. Designs on bowls and jars are repeated either two or three times, but also may be a continuously repeated motif. The repeated designs are

separated with double vertical lines with the fundamental portion of design attached to or confined within straight or banding lines.

The designs in Figures 57 to 64 were drawn from contemporary vessels and contain the most frequently repeated design elements, the arrangement of the elements in a motif, and their spatial arrangement on a vessel.

Figure 56. The Avanyu or feathered serpent

RED POLYCHROME

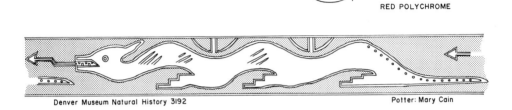

Denver Museum Natural History 3192 Potter: Mary Cain

BLACK CARVED

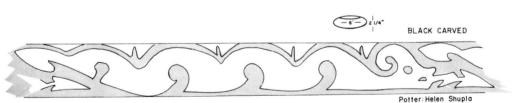

Potter: Helen Shupla

95

3 repeated designs

Deer Dancer Gift Shop Potter: Minnie

Figure 57. Designs, black-on-black

12 repeated
feather designs

11 cloud designs
(in center)

Deer Dancer Gift Shop Potter: Celestina

Flat plate
edges turned up

Deer Dancer Gift Shop Potter: Celestina

Figure 58. Designs, black-on-black

Deer Dancer Gift Shop Potter: Celestina

96

8 repeated designs

Deer Dancer Gift Shop

Figure 59. Designs, black-on-black

3 repeated designs

Deer Dancer Gift Shop
Potter: Minnie

7 1/4"
— 7 3/4"—

Figure 60. Designs, black carved

2 repeated designs

Potter: B. Tapia

2 repeated designs

Western Trading Post Potter: Francis Salazar

Figure 61. Designs, black carved

2 repeated designs

Western Trading Post Potter: B. Tapia

2 repeated designs

E 2052-46

Figure 62. Designs, red polychrome

2 repeated designs

E 2052-42

Both at State Historical Museum of Colorado

E 2052-65

Figure 63. Designs,
red polychrome wedding vases

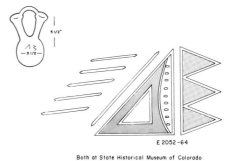

E 2052-64

Both at State Historical Museum of Colorado

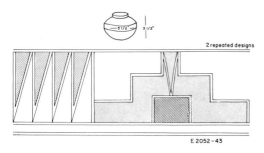

2 repeated designs

E 2052-43

Figure 64. Designs, red polychrome

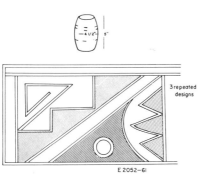

3 repeated
designs

E 2052-6l

99

APPENDIX C

Potters Active at
Santa Clara Pueblo in 1968

NAME	*AGE GROUP*
Maria Asken	30–40
Angela Baca	30–40
Candelaria Baca	50–60
Lucaria Baca	40–50
Florine Browning	30–40
Francis Chevarria	60–70
Gregarita Chevarria	60–70
Pablita Chevarria	60–70
Stella Chevarria	30–40
Raycita Dasheno	60–70
Catherine Gutierrez	50–60
Denaria Gutierrez	30–40
Dolorita Gutierrez	50–60
Faustina Gutierrez	50–60
Laurencita Gutierrez	40–50
Luther Gutierrez	50–60
Pauline Naranjo (daughter)	20–30
Margaret Gutierrez	30–40
Petra Gutierrez	50–60
Pula Gutierrez	30–40
Sandra Sue Gutierrez (daughter)	10–20

NAME	AGE GROUP
Julia Martinez	50–60
Three daughters (no names given)	10–30
Barbarita Naranjo	40–50
Veronica (daughter)	10–20
Candelaria Naranjo	30–40
Belah Naranjo (daughter)	10–20
Celestina Naranjo	50–60
Christina Naranjo	60–70
Elizabeth Naranjo	30–40
Everista Naranjo	60–70
Margarita Naranjo (daughter)	40–50
Flora Naranjo	40–50
Ramon Naranjo (husband)	40–50
Frances Salazar (daughter)	30–40
Barbara Martinez (daughter)	20–30
Glenda Naranjo (daughter)	10–20
Ronald Velarde (grandson)	10–20
Yolanda Velarde (granddaughter)	10–20
Sophie Velarde (granddaughter)	10–20
Isabele Naranjo	30–40
Madeline Naranjo	50–60
Jose G. Naranjo (husband)	50–60
Mrs. Jose C. Naranjo	50–60
Teresita Naranjo	50–60
Raycita Padilla	50–60
Pasquilita (no last name given)	30–40
Carmelita Romero	50–60
Clara Shiji	40–50
Helen Shupla	50–60
Kenneth Shupla (husband)	50–60
Lupita Silva	30–40
Nestora Silva	80–90
Adelaida Sisneros	50–60
Olivia Sisneros	50–60
Ramona Sisneros	30–40

NAME	AGE GROUP
Anita Swazo	30–40
May Swazo (daughter)	16
Clara Swazo	50–60
Marie Swazo	50–60
One daughter (no name given)	30–40
Geraldine Naranjo (granddaughter)	10–20
Camilio Tafoya°	60–70
Grace Medicine Flower (daughter)	30–40
Celeste Tafoya	30–40
Crescentia Tafoya	40–50
Laurencita Tafoya	60–70
Legoria Tafoya	50–60
Two daughters (no names given)	
Sue Tafoya (daughter)	10–20
Lucaria Tafoya	60–70
Margaret Tafoya	60–70
Lee Tafoya (son)	(?)
Madeline Tafoya	50–60
Joe A. Tafoya (husband)	50–60
Mida Tafoya	30–40
Ethel Tafoya (daughter)	10–20
Pasquilita Tafoya	40–50
Severa Tafoya	70–80
Ann Taliman	50–60
Belen Tapia	40–50
Ernest Tapia (husband)	50–60
Anna (daughter)	10–20
Lou Lou (daughter)	10–20
Paul (son)	10–20
Minnie Vigil	30–40

°Camilio Tafoya's son, Joseph Lonewolf, whose distinctive sgraffito pottery has won wide recognition, was not working at the pueblo in 1968.

Glossary

animalitos	Modeled clay replicas of animals.
Avanyu	The feathered serpent.
bowl	A restricted-rimmed or unrestricted-rimmed vessel spheroid or ellipsoid in shape.
burnish	Used synonymously with the word "**polish**," meaning to exert pressure by rubbing on a wet clay surface with a hard tool or polishing stone to achieve a degree of luster.
crazing°	Small separations in the slip caused by dry shrinkage or firing shrinkage.
ellipsoid°	A shape described by its geometric solid form, oblong in shape, or a vessel of this shape that can be formed by cutting the solid above or below the equator or center point.
facets	Small grooves or troughs on the surface of a vessel left by the action of the polishing stone.
firecloud°	Localized discoloration caused by careless firing.
floated surface°	A vessel surface that has been moistened to bring the fine particles of clay to the surface and then worked with a hard tool to polish it.
flux°	Any substance or impurity in clay that hastens fusion during firing.
guaco	A vegetable paint prepared from the Rocky Mountain beeweed (*Cleome integrifolia*).
kajape	A modeling spoon made from either gourds or coconut shells.
leather hard°	The stage in drying a vessel in which the clay is flexible but tough.
matte	Without luster; a dull finish.

micaceous clay°	A residual clay used in modeling pottery that contains a large percentage of mica.
mica sparkles	The reflection of mica when held in the light.
micro spalling°	Minute spalling. *See* SPALLING
oblique indentations	Lines impressed into damp clay that are diagonal to the rim or body.
orifice	The opening or mouth of a vessel.
ovaloid°	A geometric solid form egglike in shape, or a vessel of this shape that can be formed by cutting the solid above or below the equator or center point.
polish°	To rub the wet clay on the surface of a vessel with a hard smooth tool to give it luster.
polishing stone	A smooth stone used to rub the wet clay to compact or redistribute the clay particles.
polychrome	Pottery on which more than one color of paint has been used for decoration.
puki	A receptable, usually a ceramic dish or bowl, in which the modeled clay base is placed to facilitate rotation during the completion of a vessel.
recurved rim	The rim of a vessel that has been bent, bowed, or curved backward or outward.
restricted rim°	The orifice of a vessel that has a diameter smaller than the maximum vessel diameter.
semiglossy°	A degree of luster, a property that results from the way a surface reflects light.
shrinkage (dry)°	Contractions of the slip from the base clay with accompanying buckling or wrinkling, created by the thin layer of wet clay (slip) drying out.
sintering	The condition during firing in which the edges of the clay particles soften sufficiently to adhere to each other.
slip°	A suspension of clay in water.
spalling°	Pitting caused by the swelling of muscovite mica during firing, forcing off bits of the paste or slip.
spheroid°	A geometric solid form round in shape, or a vessel of this shape that can be formed by cutting the solid above or below the equator or center point.
stirrup	A handle connecting two spouts, such as on the wedding jar.

stress cracks Small separations caused by the pressure exerted on the plastic clay while shaping the vessel.

unrestricted rim* An orifice of a vessel that has the maximum vessel diameter.

vase (Santa Clara) An ovaloid vessel with an emphasized neck and restricted orifice.

welled bottoms Concave or indented bases.

*Shepard 1965

Bibliography

The Amerind Foundation, Inc. 1969. *Casas Grandes Pottery Types.* Eleventh Ceramic Conference. Dragoon, Ariz.

Bandelier, Adolph F. 1883. *Historical Introduction to Studies among the Sedentary Indians in New Mexico.* Papers of Archaeological Institute of America, American Studies Series no. 1. Boston, Mass.

Beals, Ralph L., and Harry Hoijer. 1965. *An Introduction to Anthropology.* New York: Macmillan Co.

Breternitz, David A. 1966. *An Appraisal of Tree-Ring Dated Pottery in the Southwest.* Anthropological Papers of the University of Arizona, no. 10. Tucson: University of Arizona Press.

Bunzel, Ruth L. 1929. *The Pueblo Potter: A Study in Creative Imagination in Primitive Art.* Columbia University Contributions to Anthropology, vol. 8. New York: Columbia University Press.

Chapman, Kenneth M. 1933. *Pueblo Indian Pottery: Specimens in the Collection of the Indian Arts Fund*, vol. 1. Nice, France: O. Szwedzicki.

———. 1936. *The Pottery of Santo Domingo Pueblo.* Memoirs of the Laboratory of Anthropology, vol. 1. Santa Fe, N.M.

———. 1938. *Pueblo Indian Pottery of the Post Spanish Period.* Laboratory of Anthropology Series, Bulletin no. 4. Santa Fe, N.M.

———. 1970. *The Pottery of San Ildefonso Pueblo.* School of American Research Monograph Series, no. 28. Albuquerque: University of New Mexico Press.

Coolidge, Mary Roberts. 1929. *The Rain Makers: Indians of Arizona and New Mexico.* Boston: Houghton Mifflin Co.

Curtis, Edward S. 1926. *The North American Indian*, vol. 17. Norwood, Mass.: Plimpton Press.

d'Azevedo, Warren L. 1958. "A Structural Approach to Esthetics: Toward a Definition of Art in Anthropology." *American Anthropologist*, vol. 60, no. 4.

Di Peso, Charles C. 1968a. "Casas Grandes and the Gran Chichimeca." *El Palacio*, vol. 75, no. 4.

———. 1968b. "Casas Grandes: A Fallen Trading Center of the Gran Chichimeca." *The Masterkey*, vol. 42, no. 1.

Dixon, Keith A. 1964. "The Acceptance and Persistence of Ring Vessels and Stirrup Spout Handles in the Southwest." *American Antiquity*, vol. 29, no. 4.

Douglas, Frederick H. 1931. *Santa Clara and San Juan Pottery.* Denver Art Museum Leaflets, no. 35.

————. 1933. *Modern Pueblo Pottery Types.* Denver Art Museum Leaflets, nos. 53–54.

Dozier, Edward. 1961. "Rio Grande Pueblos." In *Perspectives in American Indian Culture Change,* Edward H. Spicer, ed. Chicago: University of Chicago Press.

————. 1970. *The Pueblo Indians of North America.* New York: Holt, Rinehart and Winston.

Eggan, Fred. 1950. *Social Organization of the Western Pueblos.* University of Chicago Publications in Anthropology. Chicago: University of Chicago Press.

Fontana, Bernard L., William J. Robinson, Charles W. Cormack, and Ernest E. Leavitt, Jr. 1962. *Papago Indian Pottery.* American Ethnological Society Monograph. Seattle: University of Washington Press.

Gladwin, Harold S. 1930. *A Method for the Designation of Southwestern Pottery Types.* Gila Pueblo, Medallion Papers, no. 15. Globe, Ariz.

Goddard, Pliny Earle. 1913. "Indians of the Southwest." *American Museum of Natural History Handbook,* Series no. 2. New York.

Guthe, Carl E. 1925. *Pueblo Pottery Making: A Study at the Village of San Ildefonso.* Papers of the Southwest Expedition, no. 2. New Haven, Conn.: Yale University Press.

Harlow, Francis H. 1967. *Historic Pueblo Indian Pottery, Painted Jars and Bowls of the Period 1600-1900.* Los Angeles: Monitor Press.

Harrington, J. P. 1916. "The Ethnography of the Tewa Indians." *Twenty-ninth Annual Report.* Washington, D.C.: Bureau of American Ethnology.

Hawley, Florence M. 1936. *Field Manual of Prehistoric Southwestern Pottery Types.* University of New Mexico Bulletin 291, Anthropological Series, vol. 1, no. 4. Albuquerque, N.M.

————. 1950. "Big Kivas, Little Kivas, and Moiety Houses in Historical Reconstruction." *Southwestern Journal of Anthropology,* vol. 6, no. 3.

Hewett, Edgar L. 1937. *Indians of the Rio Grande Valley.* Albuquerque: University of New Mexico Press.

————. 1938. *The Pajarito Plateau and Its Ancient People.* Albuquerque: University of New Mexico Press.

Hewett, Edgar L., and Bertha P. Dutton. 1945. *The Pueblo Indian World.* Albuquerque: University of New Mexico Press.

Hill, Willard W. 1940. Unpublished manuscript on Santa Clara Pueblo. Albuquerque, New Mexico.

Hodge, Frederick W. 1912. *Handbook of American Indians North of Mexico.* Bureau of American Ethnology, Bulletin no. 30, pt. 2. Washington, D.C.

Hodges, Henry. 1964. *Artifacts: An Introduction to Primitive Technology.* New York: Frederick A. Praeger.

Hoebel, Adamson E. 1966. *Anthropology: The Study of Man.* New York: McGraw-Hill Book Co.

Jeançon, Jean A. 1906. Unpublished field notes on Santa Clara Pueblo. Denver Art Museum.

Johnson, Willard. 1925. Indian Arts Fund, Bulletin no. 1. Santa Fe, N.M.

Kidder, Alfred. 1915. *Pottery of the Pajarito Plateau and Some Adjacent Regions in New Mexico.* Memoirs of the American Anthropological Association, vol. 2, pt. 6.

Lambert, Marjorie F. 1966. *Pueblo Indian Pottery: Materials, Tools, and Techniques.* Santa Fe: Museum of New Mexico Press.

Laski, Vera. 1958. *Seeking Life.* Memoirs of the American Folklore Society, vol. 50. Philadelphia.

LeViness, Thetford. 1968. "Indian Wares in a Historical Setting." *The Quarterly of the Southwestern Association on Indian Affairs,* vol. 5, nos. 1–2.

Lister, Robert H., and Florence C. Lister. 1969. *Earl H. Morris Memorial Pottery Collection: An Example of 16 Centuries of Prehistoric Ceramic Art in the Four Corners of Southwestern United States.* University of Colorado Anthropology Papers, no. 16. Boulder: University of Colorado Press.

Marriott, Alice. 1948. *Maria: The Potter of San Ildefonso.* Norman: University of Oklahoma Press.

Martin, P. S., and E. S. Willis. 1940. *Anasazi Painted Pottery in the Field Museum of Natural History.* Chicago Natural History Museum, Anthropology Memoirs, no. 5.

Matson, Frederick R. 1965. *Ceramics and Man.* Viking Fund Publications in Anthropology, no. 41.

Mera, Harry P. 1934. *A Survey of Biscuit Wares in Northern New Mexico.* Laboratory of Anthropology, Technical Series, Bulletin no. 6. Santa Fe, N.M.

———. 1935. *Ceramic Clues to the Prehistory of North Central New Mexico.* Laboratory of Anthropology, Technical Series, Bulletin no. 8. Santa Fe, N.M.

———. 1937. *The Rain Bird: A Study in Pueblo Design.* Memoirs of the Laboratory of Anthropology, vol. 2. Santa Fe, N.M.

———. 1939. *Style Trends of Pueblo Pottery in the Rio Grande and Little Colorado Cultural Areas from the Sixteenth to the Nineteenth Century.* Memoirs of the Laboratory of Anthropology, vol. 3. Santa Fe, N.M.

Munsell Color Company, Inc. 1954. *Munsell Soil Color Charts.* Baltimore, Md.

Ortiz, Alfonso. 1969. *The Tewa World.* Chicago: University of Chicago Press.

Parsons, Elsie Clews. 1929. "The Social Organization of the Tewa of New Mexico." Memoirs of the American Anthropological Association, no. 36.

———. 1939. *Pueblo Indian Religion.* Chicago: University of Chicago Press.

Raynolds, Frances R. 1941. "Questionnaire on Design Elements." *Denver Art Museum News Letter,* no. 35. Denver, Colo.: Clearinghouse for Southwestern Museums.

Reed, Eric K. 1943. "The Southern Tewa Pueblos in the Historic Period." *El Palacio*, vol. 50, no. 2.

———. 1946. "The Distinctive Features and Distribution of the San Juan Anasazi Culture." *Southwestern Journal of Anthropology*, vol. 2, no. 3.

———. 1949. "Sources of Upper Rio Grande Culture and Population." *El Palacio*, vol. 56, no. 6.

Schroeder, Gail D. 1964. "San Juan Pottery: Methods and Incentives." *El Palacio*, vol. 71, no. 1.

Shepard, Anna. 1965. *Ceramics for the Archaeologist*. Carnegie Institution of Washington, Publication 609. Washington, D.C.

Sides, Dorothy S. 1961. *Decorative Art of the Southwestern Indians*. New York: Dover Publications.

Smith, Anne M. 1966. *New Mexico Indians: Economic, Educational and Social Problems*. Museum of New Mexico Research Records, no. 1. Santa Fe, N.M.

Spinden, Herbert J. 1911. "The Making of Pottery at San Ildefonso Pueblo." *The American Museum Journal*, vol. 11. New York: The American Museum of Natural History.

Stevenson, J. 1883. "Illustrated Catalogue of Collections Obtained from the Indians of New Mexico and Arizona in 1879." *Second Annual Report*. Washington, D.C.: Bureau of American Ethnology.

Stubbs, Stanley A., and W. S. Stallings, Jr. 1953. *The Excavation of Pindi Pueblo, New Mexico*. Monographs of the School of American Research, no. 18. Albuquerque: University of New Mexico Press.

Tanner, Clara Lee. 1944. "Pottery of the Modern Southwest Indians." *The Kiva*, vol. 10, no. 1.

Underhill, Ruth. 1944. *Pueblo Crafts*. Indian Handicraft Series, vol. 5. United States Department of the Interior, Bureau of Indian Affairs, Branch of Education. Washington, D.C.

Wendorf, Fred. 1953. *Salvage Archaeology in the Chama Valley, New Mexico*. Monographs of the School of American Research, no. 17. Albuquerque: University of New Mexico Press.

Wendorf, Fred, and Eric K. Reed. 1955. "An Alternate Reconstruction of the Northern Rio Grande Prehistory." *El Palacio*, vol. 62, no. 3.

Wheeler, George M. 1879. *United States Geographical Surveys, West of the One Hundredth Meridian, Archaeology*, vol. 7. Washington, D.C.: U.S. Government Printing Office.

Wormington, H. M., and Arminta Neal. 1951. "The Story of Pueblo Pottery." *Museum Pictorial*, no. 2. Denver Museum of Natural History.

Index

114